Magnificent Moments

Magnificent Moments

THE WORLD'S GREATEST WILDLIFE PHOTOGRAPHS

EDITED AND INTRODUCED BY
GEORGE H. HARRISON

WILLOW CREEK PRESS

MINOCQUA, WISCONSIN

ISBN 1-57223-023-1

Published by Willow Creek Press
 an imprint of Outlook Publishing
 P.O. Box 147
 Minocqua, WI 54548

George H. Harrison, Author/Editor
Kit Harrison, Associate Editor
Designed by Patricia Bickner Linder

For information on other Willow Creek titles,
call 1-800-850-9453 or write to the address above.

Library of Congress Cataloguing-in-Publication Data

Magnificent moments : the world's greatest wildlife photo-
 graphs / edited and introduced by George H. Harrison.
 p. cm.
 ISBN 1-57223-023-1 (hardcover : permanent paper)
 1. Wildlife photography I. Harrison, George H.
 TR729.E54M35 1995
 778.9'32--dc20 95-7008
 CIP

Printed in Hong Kong.

Portrait Photograph Credits

Heather Angel: Brinsley Burbidge; Anthony Bannister: David Bannister;
Jim Brandenburg: Anthony Brandenburg; Tui De Roy: Mark Jones;
David Doubilet: Gary Bell; Tim Fitzharris: self; Michael and Patricia
Fogden: self; Stephen J. Krasemann: self; Mark W. Moffett: Darlyne
Murowski; Flip Nicklin: Koji Nakamura; John Nuhn: Forest McMullin;
John Shaw: Andrea Shaw; Larry West: Gene White; Günter Ziesler: A. Hofer.

CONTENTS

INTRODUCTION 7

THE EDITORS 9

THE PHOTOGRAPHERS 13

THE PHOTOGRAPHS 21

Heather Angel 22

Anthony Bannister 28

Erwin and Peggy Bauer 34

Jim Brandenburg 40

Fred Bruemmer 46

Stephen Dalton 52

Tui De Roy 58

David Doubilet 64

Tim Fitzharris 70

Michael and Patricia Fogden 76

Howard Hall 82

Mitsuaki Iwago 88

Stephen J. Krasemann 94

Frans Lanting 100

Mark W. Moffett 106

Flip Nicklin 112

John Shaw 118

Larry West 124

Art Wolfe 130

Günter Ziesler 136

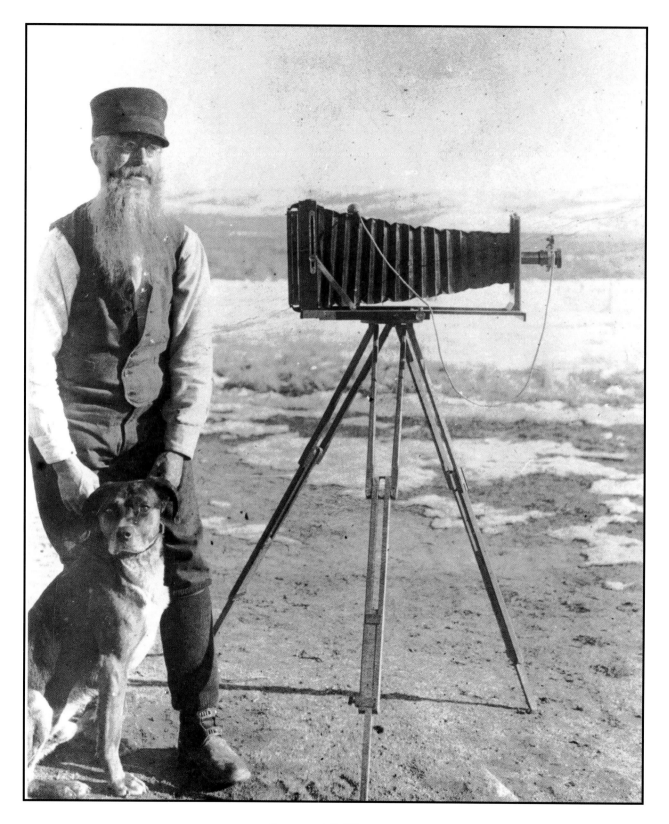

PHOTO BY A.G. WALLIHAN.
COURTESY OF DENVER PUBLIC LIBRARY, WESTERN HISTORY DEPARTMENT.

THE STORY OF WILDLIFE PHOTOGRAPHY

by George H. Harrison

The art of capturing wildlife images on film began more than 100 years ago. Though there has been a remarkable change in the technology used to photograph wildlife in the last century, the techniques, skills and patience required to produce successful wildlife images have remained just as challenging.

The pioneers of wildlife photography used expensive, cumbersome, and highly complicated photographic equipment. The black and white film, on glass plates, requiring long exposures, presented enormous challenges to the photographer of animated subjects in the wild.

Consider the A. G. Wallihans, a husband and wife team from Colorado, who worked in the 1890s, and who may have been the first wildlife photographers. They used the most primitive equipment—a large format view camera mounted on a heavy tripod, which required a black cloth to focus, and long exposures on very slow black and white plate film. Imagine dragging that heavy equipment across the kind of terrain that is inhabited by bears, elk and mountain lions. Imagine focusing under a black cloth, and expecting the subject to wait until everything is just right, and then pray that it does not move while the shutter is open? Yet, the Wallihans produced photographs that were good enough to attract the attention of Theodore Roosevelt, who wrote introductions to their two books, *Hoof, Claws and Antlers of the Rocky Mountains* (1894) and *Camera Shots at Big Game* (1904).

"In the spring of '91, I took a trip to the noted Bear River...," Wallihan wrote in *Hoof, Claw and Antlers of the Rocky Mountains*. "Climbing down the trail over 1000 feet and quite steep all the way and in places quite difficult to get down with cameras as a drawback. A yearling doe came down [on the opposite bank] and after drinking and satisfying herself that everything was right she started over [to swim across the river]. Deer swim very easily and fast and she came right towards me, and when about twenty steps from shore she turned to land above me and I took a snap shot while [the deer was] swimming..."

There were other early wildlife photographers who followed the Wallihans, including William Lyman Underwood, who set up his large view camera with a long bellows in the bow of his canoe to photograph animals in the Maine wilderness during the early 1900s.

About that same time, George Shiras III began photographing wildlife at night, using explosive flash powder to illuminate his subjects. With Teddy Roosevelt's urgings, Shiras produced the two-volume set of books *Hunting Wild Life With Camera and Flashlight*. Shiras went on to become a member of Congress and author of the Migratory Bird Act of 1913, which gave the federal government jurisdiction over waterfowl and other migratory birds that crossed state lines.

In the 1930s, Pennsylvania wildlife photographer Bob Ford used automobile batteries to power huge flood lights that illuminated woodlands for recording big game on film at night.

Ornithologists Frank Chapman and Arthur Allen, and my own father, Hal H. Harrison, pioneered photography of birds at their nests from the 1920s to the 1940s. Working in the woodlands of western Pennsylvania, Hal used a 4x5 Speed Graphic camera, big blue flash bulbs, and color sheet film with an ASA of 2. With a long electric

wire attached to storage batteries he fired his camera and flash. After each shot, Hal had to get out of his blind, walk to the camera, cock the shutter, change the bulb and film, and then walk back to the blind to wait for the bird to return. He also used an enormously heavy surveyors' tripod to hold the camera steady. I know how heavy that tripod was, because as a small boy I carried the hated thing for what seemed to be endless miles over what I thought was the world's roughest terrain. Ironically, it was that hand-me-down heavy tripod and Speed Graphic camera upon which I learned to take bird pictures myself, and began winning some photo contests for my work at the age of seven.

But all that has changed. Micro computer chips and lightweight metals and plastics have made cameras easier and more efficient to operate. With the high-tech, auto-focus, auto-wind, auto-rewind, auto-exposure, auto-flash capabilities of modern cameras, and new films that are faster, sharper and more colorful, the technical aspects of wildlife photography have been simplified. It is not unusual for the most rank of amateurs, with point-and-shoot cameras, to produce some remarkable wildlife photographs. This has been shown time and again in photo contests published by *National Wildlife* and *BBC Wildlife* magazines.

Yet, the most sophisticated electronic camera and flash equipment, with the finest, fastest films, do not guarantee a successful career in wildlife photography. High-tech equipment alone does not a great wildlife photographer make. The few people in the world who make their living as wildlife photographers work just as hard as did the old-timers to consistently record remarkable images on film. Today's successful wildlife photographers still have to know their subjects, have enormous patience, invariably devoting enormous amounts of time—days, weeks, months and even years—and have the skills required to produce great wildlife images. Just as a fisherman cannot catch fish unless his line is in the water, a wildlife photographer cannot shoot great wildlife images unless he or she is out there with camera in hand and the knowledge of what to do when the "magnificent moment" occurs.

Nor is the life of a wildlife photographer as glamorous as one might expect. The successful photographers often endure all manner of outrageous life-threatening discomforts in pursuit of their art, ranging from disease-carrying insect stings and the bites and maulings and gorings of their subjects to falling out of trees, off cliffs, and into oceans. And, it is very hard work, and often lonely. That may be why a number of the world's most respected wildlife photographers are members of a two-person team and, like the Willihans 100 years ago, they often work together in the field.

In other words, consistently great wildlife photographs don't just happen, they are made. That's what this book,

Magnificent Moments, The World's Greatest Wildlife Photographs, is all about. Each and every image featured here is accompanied by an interesting and sometimes frightening story of how it was made. For the first time, under one cover, the world's most respected wildlife photographers candidly tell their stories of how they made their best wildlife pictures.

WHO SAYS THEY ARE THE GREATEST?

The world's greatest wildlife photographs, by the world's most respected wildlife photographers? Who says so?

That challenging question had to be answered before the contents of this book could be determined.

The answer: editors. Who knows the world's best wildlife photographers better than the editors of the most respected wildlife magazines? That's why we asked each of the following editors to nominate the 20 wildlife photographers they most respected for the works they had consistently produced over the years.

The 20 photographers with the most nominations—men and women from seven countries on five continents—were invited to select the three wildlife images that they believe are their finest works.

Magnificent Moments, The World's Greatest Wildlife Photographs presents these remarkable images—and the incredible stories behind each—by the world's most respected wildlife photographers.

THE DISTINGUISHED PANEL OF EDITORS

ROSAMUND KIDMAN COX
BBC Wildlife

ROSAMUND KIDMAN COX has been the editor of *BBC Wildlife* for the past 13 years. The magazine has a readership of 1.1 million and caters to readers worldwide with all levels of interest in wildlife and environmental matters. It places particular value on the power of striking imagery.

ROBERT L. DUNNE
Ranger Rick

ROBERT L. DUNNE was born and raised in New York City, studied at Syracuse University and received a B.S. degree from New York University. He is also a graduate of Parsons School of Design. Since graduation he had held positions with *Esquire* Magazine, and the advertising agencies Batton, Barton, Durstine and Osborne, Inc., and Hockaday Associates. Dunne left his position as Experimental and Creative Art Director at Wundermann, Ricotta and Klein to join *Ranger Rick* magazine as art editor in 1966. He has been with the magazine for 28 years, the last 24 as executive editor. Dunne has been an active nature photographer for many years and has had work published in books and magazines. He co-authored two books for children.

THE EDITORS

LES LINE
Audubon

HELEN LONGEST-SLAUGHTER
Nature Photographer

LES LINE was the editor-in-chief of *Audubon* magazine from 1966 to 1991. During those 25 years, *Audubon* received many magazine awards for layout, design and photographic excellence.

Line is now a contributing editor to *Natural History*, the author or editor of 25 books on nature and conservation, and a freelance writer, editor, photographer and lecturer on natural history and wildlife photography.

Line resides in rural Amenia, New York, where he can see and photograph wildlife from his office window.

HELEN LONGEST-SLAUGHTER is a photographer, writer and photo editor for *Nature Photographer* magazine. In each issue she authors "Images of the Wilderness." She also writes and photographs feature articles, including pieces about the artistic aspects of photography. In addition to writing for *Nature Photographer*, she writes for other publications both in the U.S. and abroad. She is also the author of a series of "How-to" booklets and pamphlets for nature photographers.

JOHN NUHN
National/International Wildlife

MARY G. SMITH
National Geographic

MARGARET WILLIAMSON
Canadian Geographic

JOHN NUHN, in his 15th year as photo editor of *National Wildlife* and *International Wildlife* magazines, publications of the National Wildlife Federation, is responsible for all photographs appearing in the magazines. Prior to this position, he worked his way from assistant editor to managing editor of a small Wisconsin book publisher of large format nature, history and art books. In that capacity, he served as photo and text editor for numerous books. More recently (1992), he photo edited *Patterns in the Wild*, a book published by the National Wildlife Federation that won praise from the *Washington Post* among others.

Nuhn holds a degree in journalism from Marquette University and is a self-taught photographer.

MARY G. SMITH has worked for *National Geographic* for nearly 30 years, as assistant illustration editor and senior assistant editor of research grant projects, and for National Geographic Society books, magazines and television programs. She has a special interest and expertise in human evolution and natural history, particularly in the studies of the great apes. She has traveled extensively throughout the world in connection with her work.

Educated in London and Paris, Smith serves on the boards of the Jane Goodall Institute, the Dian Fossey Gorilla Fund, Bonobo Protection Fund, and Sister Parks.

MARGARET WILLIAMSON studied Visual Media at Capilano College in North Vancouver, B.C. Photo editor of *Canadian Geograhic* since 1992, she served as photo editor at the Canadian Wildlife Federation in Ottawa for two years, working on a special project developing a children's magazine. Before that, Williamson was a photo researcher for western Canada's largest stock agency (formerly Image Finders, now Tony Stone/Vancouver).

THE PHOTOGRAPHERS

HEATHER ANGEL

HEATHER ANGEL is based in England, but travels extensively in search of new wildlife photographs—including to the Arctic for polar bears, the Antarctic for emperor penguins, Indonesia for orangutans, and Japan in winter for cranes dancing in the snow. In addition to writing 42 books on photographic techniques, natural history and gardening topics, she writes a monthly column for *Amateur Photographer*, and markets her photographs through her own photo library.

Trained originally as a zoologist and later as a marine biologist, Heather strives to produce pictures which combine scientific accuracy with pictorial appeal. Major exhibitions of her work have been on show in China and at the Science and Natural History Museums in London.

Heather was president of The Royal Photographic Society from 1984-86. An honorary Doctorate of Science for "distinguished work in Wildlife Photography" was conferred upon her by the University of Bath in 1986. In 1994, she was appointed a professor at Nottingham University, teaching photography in the Department of Life Sciences.

ANTHONY BANNISTER

ANTHONY BANNISTER'S love of nature began during a childhood spent in the rolling Cotswold Hills of England, and developed when his family emigrated to South Africa.

After training and working in electronics, he turned his talent as an amateur photographer into a career as a highly successful freelance professional photographer.

During the late 1970s, Anthony and his wife, Barbara, spent two years with a band of Kalahari Bushmen, producing a unique in-depth photographic record of the last of these gentle and forgotten hunter-gatherer people.

Ten successful books of his work have been published, and Anthony's photographs are in demand worldwide.

Today, he spends his time traveling all over the world undertaking photographic assignments for clients that include movie studios, international corporations, advertising agencies, magazines, environmental agencies, and aid organizations.

ERWIN AND PEGGY BAUER

ERWIN AND PEGGY BAUER, natives of the Midwest and lifelong, hard core environmentalists, have been photographing nature, adventure travel and wildlife for an aggregate 75 years. Together, they have worked in the most remote corners of all continents except Europe, focusing on rare and endangered species as well as more common ones.

Erwin and Peggy live today on property adjoining the Beartooth-Absaroka wilderness in Montana, not far from Yellowstone National Park. They are well known for hundreds of feature articles and photo covers on many American and international conservation magazines. In recent years they have concentrated on producing natural history books. Some of the titles include *Wildlife Adventures With a Camera*; *Wild Alaska*; *Yellowstone*; *Whitetails*; *Antlers*; *Wild Dogs*; and *From Baja to Barrow*.

JIM BRANDENBURG

JIM BRANDENBURG began his career as a natural history photographer and film maker while majoring in studio art at the University of Minnesota, Duluth.

He went on to become Picture Editor at the Worthington *Daily Globe* in southern Minnesota. While at the *Daily Globe*, he began free-lancing for *National Geographic* magazine.

In 1978, Jim left the *Daily Globe* to become a contract photographer for *National Geographic*. He has since worked on numerous projects around the world for the magazine. His work in Manchuria was featured in a National Geographic book on China; his work on the Highlands of Scotland was featured in another National Geographic book, *Discovering Britain and Ireland*.

In addition, Jim has done work for *Life, Audubon, Smithsonian, Natural History, World, Geo, Airone, Modern Maturity, BBC Wildlife, National Wildlife* and numerous other national and international publications.

In 1981, and again in 1983, he was named "Magazine Photographer of the Year" by the National Press Photographer's Association. In 1988, he was named "Kodak Wildlife Photographer of the Year" by the Natural History Museum-London and *BBC Wildlife* magazine.

FRED BRUEMMER

FRED BRUEMMER is a Canadian wildlife writer and photographer who specializes in the Arctic and subarctic regions of the world. During the past 30 years, he has traveled extensively in the Canadian north, in Alaska, Siberia, Lapland, Greenland and Spitsbergen in pursuit of stories and photographs of wildlife.

He has written and illustrated 17 books about the Arctic, its people and its wildlife. Among them, *The Arctic World; Arctic Animals; The Narwhal: Unicorn of the Sea;* and *Arctic Memories*. He has contributed about a thousand articles, primarily on Arctic subjects, to magazines such as *National* and *International Wildlife, Natural History, Canadian Geographic*, and other magazines in North America and Europe.

STEPHEN DALTON

STEPHEN DALTON studied under Professor Margaret Harker at the Regent Street Polytechnic School of Photography in London.

In the early 1970s, his ambition to photograph insects and birds in free flight and in natural settings led to pioneering work in high-speed nature photography, employing what were then sophisticated electronic flash and triggering techniques.

Stephen has been awarded numerous distinctions, including Kodak scholarships, the Hood Medal, the Nikon Award, and the highest of photographic accolades, the Royal Photographic Society's Silver Progress Medal. He is an Honorary Fellow of the Royal Photographic Society.

A Stephen Dalton photograph of an insect in flight was included in the *Voyager* 1 and 2 spacecrafts, expected to last a billion years, as part of records conveying something of the science and culture of mankind to extra-terrestrial beings.

Stephen's pictures have appeared in books and magazines all over the world. His own books include *Born on the Wind; The Miracle of Flight; Caught in Motion; The Secrets of an Oakwood; At the Water's Edge;* and *Vanishing Paradise*.

Tui De Roy

Tui De Roy left her native Belgium at the age of two, when her parents moved to the Galapagos Islands to lead a pioneering life. At 13, she decided to catalog the nesting behavior of every Galapagos bird species, little realizing the scope of the task. Two years later, she exposed her first roll of color film, of which some images were later published.

In the last 15 years, Tui has traveled widely, from the Arctic to the Antarctic, from Patagonia to the Himalayas, from the Amazon jungle to the desert islands of Baja California in pursuit of wildlife photography. She has written and illustrated several books on the Galapagos, co-authored one on Antarctica, and produced numerous articles for nature magazines in the United States, Europe, Japan and South America. Tui is Roving Editor for *International Wildlife* and Associate Editor for *Ocean Realm*. She has lectured extensively for scientific and conservation institutions in the U.S., was featured in an *Audubon Special* TV program, and is a member of the General Assembly of the international Charles Darwin Foundation for the Galapagos Islands.

In 1992, Tui and her partner, Mark Jones, moved to the seclusion of Golden Bay on New Zealand's South Island where they are building a new home among the tree ferns along the beach.

David Doubilet

David Doubilet began snorkeling at the age of 12 in the cold, green seas off the north New Jersey coast. By the age of 13, he was taking pictures above and below the sea with a pre-war Leica.

David's first work for *National Geographic* was published in 1972. Since then, as a contract photographer, he has produced 39 stories for the magazine. His warm-water work has taken him throughout Micronesia, Australia and New Guinea in the Pacific; Sri Lanka and the Seychelles in the Indian Ocean; and all over the Caribbean. The Red Sea, his favorite "underwater studio," has produced at least 10 different stories for *National Geographic*. His cold-water work has immersed him off the coast of England; in Scotland's Loch Ness; into the teeming water of the Galapagos; around the mysterious shores of Japan; and deep in Canada's Pacific Northwest. He has also worked off the entire eastern coast of the United States—from Maine to the Florida Keys—and in California.

Most of David's photographic time is spent working for the National Geographic Society and its diverse publications.

His books include *Light in the Sea*; *Pacific: An Undersea Journey*; and *Under the Sea From A to Z*, written by his wife, Anne L. Doubilet, with photographs by David.

Tim Fitzharris

Tim Fitzharris is a nature writer, photographer, and producer of illustrated books. He has written and illustrated 15 books on nature, including *The Audubon Society Guide to Nature Photography* and *The Sierra Club Guide to 35mm Landscape Photography*. He is a professional advisor and feature writer for *Outdoor Photographer* magazine and frequent columnist for *Wildlife Conservation* magazine. His wildlife photographs have been exclusively featured in more than 20 calendars and exhibited by the National Museum of Canada. He has lectured widely on photography, including lecture series for Cornell University and the Royal Canadian Geographical Society. He lives with his wife, Joy, in Santa Fe, New Mexico.

MICHAEL AND PATRICIA FOGDEN

MICHAEL AND PATRICIA FOGDEN began their careers as research biologists. Michael studied Zoology at Oxford University and did undergraduate research on gulls under Nobel Prize winner Dr. Niko Tinbergen. For his Ph.D. thesis, he worked three years in Borneo, studying the seasonality and population dynamics of rainforest birds.

Patricia studied Zoology and Botany at Manchester University and obtained her Ph.D. at London University, with her thesis on dentition of bats. She spent six years as a lecturer at the University of Hong Kong and did research on the ecology and behavior of rodents. She also wrote the book *The Mammals of Hong Kong*.

Since 1968, Michael and Patricia have worked together. In Uganda, from 1968 to 1972, they researched the comparative ecology and physiology of resident and migrant warblers. From 1973 to 1978, they worked on range management problems in the Chihuahuan and Sonoran Deserts in Mexico. In 1978, they resigned from their research posts to become freelance writers and photographers specializing in natural history subjects.

Michael and Patricia Fogden's photographs appear regularly in books published by Time-Life, National Geographic Society, National Audubon Society, Chanticleer Press, Reader's Digest, Collins and the BBC. Their articles appear in magazines throughout the world. They wrote the book *Animals and Their Colours*; collaborated with Dr. Adrian Forsyth on *Portraits of the Rainforest*; and recently completed *Snakes—The Evolution of Mystery in Nature* with Professor Harry Greene.

HOWARD HALL

HOWARD HALL is a natural history film producer specializing in marine wildlife. The recipient of five Emmy awards, Howard has produced award-winning films for the PBS series *Nature*, the BBC, and for *National Geographic Specials*.

Howard's still photography has been widely published, and he is a contributing editor for *International Wildlife* and for *Ocean Realm* magazines.

MITSUAKI IWAGO

MITSUAKI IWAGO, born in Tokyo, has been involved in photography since he was a child. After graduating from college, he began to pursue a career in photography. Since that time, he has studied almost every area on earth. A keen observer of animal behavior, he has used this extensive knowledge in pursuit of his photography. His photographs and feature articles have appeared in many publications, including *National Geographic*. *Life* magazine selected him as one of the finest photographers of the 1980s. *Serengeti: Natural Order on the African Plain*, a collection of his photographs made during his stay in Africa's Serengeti National Park from 1982 to 1984, is a worldwide best-seller. He began to produce a video series, *Mitsuaki Iwago's Nature World*, in 1989, which he continues in partnership with NHK.

STEPHEN J. KRASEMANN

STEPHEN J. KRASEMANN grew up in the north woods of Wisconsin where his interest in wild things was nurtured through his formative years. After earning a degree in journalism from the University of Wisconsin, the hunter with a gun began hunting wildlife with a camera and made a career of wildlife photography that has taken him on assignments around the world.

Stephen has filmed nature segments for *Sesame Street*, and made still photographs for the Walt Disney movie *Never Cry Wolf*. He has worked on magazine assignments for *Audubon, National Geographic, International Wildlife, Natural History, Reader's Digest* and *Newsweek* in Africa, Europe and North America. He spent two years tracking mountain lions on assignment for the German magazine *Geo*.

Books by Stephen Krasemann include *Diary of an Arctic Year; Preserving Eden—The Nature Conservancy; True North;* and *Way of the Whitetail*.

The recipient of four Picture of the Year Awards from the National Press Association, Stephen has also been named "BBC Wildlife Photographer of the Year."

He currently resides in a remote area of Montana where his work is at his front door.

FRANS LANTING

FRANS LANTING was born in Rotterdam, the Netherlands. After obtaining a Master's degree in environmental economics, he came to the United States to study environmental planning, but switched, to pursue a career in photography. In the past decade, he has been a professional nomad, documenting wildlife and man's relationship with nature around the world. His work has been published in leading magazines all over the world.

Frans' photography has been commissioned frequently by the National Geographic Society, for which he has carried out exclusive assignments such as a foot safari to search for the last white rhinos in Zaire, and a photographic coverage of the fabled pygmy chimpanzee in the rainforest of the Congo Basin. His groundbreaking work in Madagascar led to his book *Madagascar: A World Out of Time*. A portion of his acclaimed coverage of the Okavango Delta, published in book form as *Okavango: Africa's Last Eden*, appeared in *National Geographic* as the longest wildlife story ever published in the 100-year history of the magazine. His other books include *Islands of the West, Peace on Earth,* and *Forgotten Edens*.

He has received numerous awards, including top honors in 1988 and 1989 from World Press Photo. In 1991, Sir David Attenborough presented to him the prestigious title of "BBC Wildlife Photographer of the Year."

MARK W. MOFFETT

MARK W. MOFFETT earned his B.A. at Beloit College, Wisconsin, and taught himself macro photography to document his 1989 Harvard Ph. D. on the behavior and evolution of marauder ants in Asia. After two years curating ants at Harvard's Museum of Comparative Zoology, he continues research based there, interspersed with photography, writing, and public lecturing about the tropics.

Mark's photographs were first published in 1986, by *National Geographic*. He has since shot a dozen stories for the magazine, which has called him a "world-roving zoologist." The photos selected for this book came from his recent book *The High Frontier: Exploring the Tropical Rain Forest Canopy* and the *National Geographic* stories "All Eyes on Jumping Spiders" and "Life in a Nutshell."

FLIP NICKLIN

FLIP NICKLIN has virtually lived in the ocean since he started diving at the age of 11. He worked first as a diving instructor and then as a dive shop manager before turning to underwater photography.

Following his first assignment for *National Geographic* in 1976 as a diving assistant, he photographed marine life for *National Geographic* around the world, producing ten major articles through the 1980s and 1990s. He is now a contract photographer for *National Geographic*.

Flip's work has also appeared in dozens of other magazines in the U.S., Europe and Japan. His books include *With the Whales* and *Whales For Kids*.

When not diving with a camera, Flip splits his time between Washington, D.C. and Coupeville, Washington.

JOHN SHAW

JOHN SHAW is an internationally acclaimed nature photographer whose work has been extensively published in a variety of magazines, including *Outdoor Photographer*, *National Wildlife*, *Natural History*, *Sierra* and *Audubon*. The author/photographer of four best-selling books, *John Shaw's Landscape Photography*, *John Shaw's Focus on Nature*, *John Shaw's Close-ups in Nature* and *The Nature Photographer's Complete Guide to Professional Field Techniques*, his work is also visible in numerous calendars and advertisements. John is an experienced leader of photo workshops and tours, and has produced a workshop series on videotape. He and his wife, Andrea, currently reside in Colorado Springs.

LARRY WEST

LARRY WEST has been creating images of the natural world for more than 30 years. His photography is the result of his life-long love affair with the out-of-doors, its inhabitants, and its places. He is also a leading advocate of "environmentally friendly" photography, emphasizing concern and care for the environment and its inhabitants.

His images and how-to articles have appeared in virtually every natural history oriented magazine, as well as in books and educational texts.

Larry also teaches week-long workshops and weekend seminars, and is contemplating his third book in a series published by Stackpole Books. Current titles includes *How to Photograph Birds* and *How to Photograph Insects and Spiders.*

ART WOLFE

ART WOLFE'S wildlife photography and landscape art reflects the strong background in nature and composition he received at the University of Washington.

Art is frequently published in *National Geographic, National Wildlife, Smithsonian, Natural History, GEO* and *Audubon,* and numerous other U.S., European and Japanese magazines.

Imagery of Art Wolfe was followed by other Art Wolfe books, including *Alakshak; Owls: Their Life and Behavior; The Kingdom; Chameleons, Dragons in the Trees; Light on the Land; Masters of Disguise: A Natural History of Chameleons; Bears: Their Life and Behavior; The Art of Nature Photography; Penguins, Puffins & Auks;* and *Migrations.* He has also been a contributing photographer to numerous other books.

On Location with Art Wolfe is a video filmed in Alaska's Denali National Park and Kenai Peninsula. Art is also featured in Kodak's instructional program series *Techniques of the Masters,* and is the host of *American Photo Magazine's Safari* on ESPN.

GÜNTER ZIESLER

GÜNTER ZIESLER, born in Munich in 1939, has loved nature since his early childhood. At about the age of 15, he began photographing zoo animals with his father's old Voightländ camera. Yet it took him 20 more years to turn his hobby of nature photography into his profession.

He now travels around the world as a freelance photographer. For the past 14 years, he has been accompanied by his partner, biologist Angelika Hofer. Their joint work has produced many magazine contributions, as well as eight books: *Safari, Tiger, The Lion Family Book, South America, Ein Gänsesommer, Tagebuch einer Gänsemutter, Urwaldpfade* and *Gänsekinder.*

THE PHOTOGRAPHS

Heather Angel
ENGLAND

• • • • • • • • • • • • • • • • • •

It is ironic that my whole life now evolves around wildlife photography, because I never had any ambition to be a photographer. Indeed, I had not even exposed a single frame of film until I was given an Exakta for my 21st birthday. With a zoology degree behind me, I set off on a SCUBA expedition to Norway. There, in the fjords, I focused my new camera on marine life and one of the first pictures I ever made was of a sea anemone.

Since then, I have broadened my horizons to include any sized subject from any habitat. Each year I make six to eight long-haul trips—including several to the United States, where travel is easy and the language is no problem. Even though I greatly enjoy

FIRE DANCE ON THE MARA

During a July visit to Kenya's Masai Mara Reserve, I was dismayed to discover that areas of unpalatable, long, dry grass were being burned to encourage appetizing green shoots for the grazing herds. For a whole week, my instinct had been to seek pictures in the opposite direction from the fires.

Then, returning to the lodge at the end of a game drive one day, we rounded a corner to see a distant fire line snaking towards the road below. Mesmerized by the ever-changing pattern of the irregular orange lines eating into the grass, leaving charred stubble in their wake, I became intrigued by mobile black and white spots—unidentifiable to the naked eye—in front of the advancing fire. Binoculars enlarged and clarified the images to reveal they were white storks purposefully walking ahead of the flickering flames.

As we approached, I sensed our driver was planning to drive past the flames before stopping, so we could have a clear view of the storks with the flames behind. Suddenly, I urged him to stop ahead of the fire as I realized here was one of the most exciting images I had ever seen anywhere on safari. Engulfed by the heat haze, no part of the scene was sharply focused; instead, ghostlike abstracted images—reminiscent of the way French Impressionists interpreted their scenes—were dancing before my eyes.

When I focused the camera, it became clear that an abundant food source, requiring little expenditure of energy, was the reason that the birds were tolerating what must have been considerable heat. Closer scrutiny with binoculars revealed constant waves of crickets and locusts leaping and flying away from being roasted alive, only to face death by predation within moments.

Nikon F4 camera, Nikkor 200mm lens, Kodachrome 200 film.

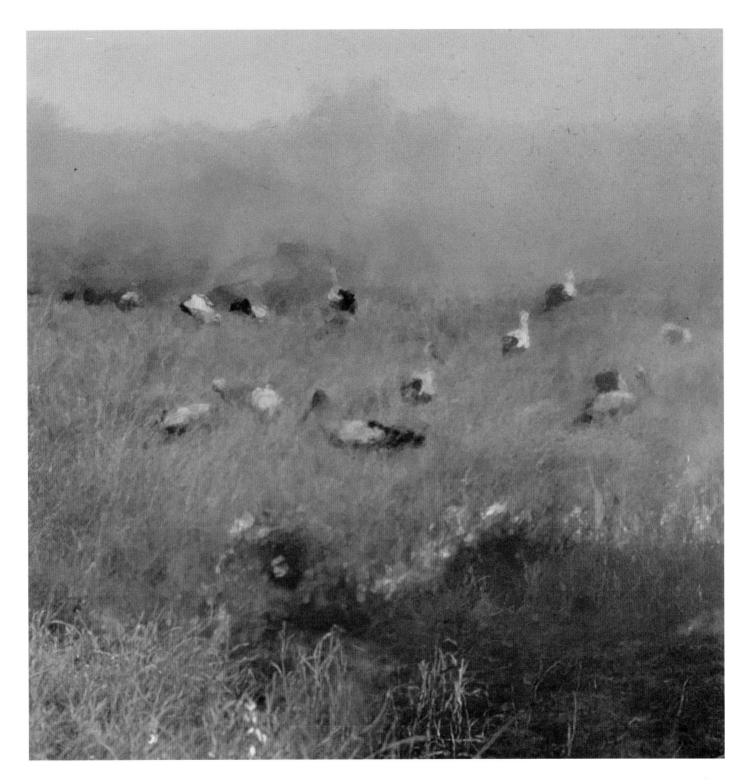

FIRE DANCE ON THE MARA

Heather Angel

traveling overseas, I don't neglect my home patch in England, where I keep an ongoing record of my wildlife visitors.

Very rarely do I take commissions. I much prefer to shoot what captures my eye. In this way I don't have to work under pressure in inclement weather, when animals fail to appear, or to produce predictable work just to please someone else.

I count myself fortunate indeed to have found a niche relatively early in my working life which has taken me to so many exciting locations, to observe and photograph wild animals in their natural habitats, free from the pressures of publishers' deadlines.

My wildlife photography generally falls into one of two categories: planned and opportunist. Many of my photographs are the result of months of research and meticulous planning to ensure I am in the right place at the right time. Since there is often a narrow window of opportunity when a particular activity takes place, a year could pass before the event is repeated. The three photographs I have selected as my best were completely unplanned, in which luck played a part in capturing these magnificent moments.

PAWS AND JAWS

Several years later, also in Kenya, I was dressing for dinner when I heard monkeys giving their distinctive alarm calls—a sure sign that a large cat was in the vicinity. As I approached the bar, I saw a leopard attempt to steal bait laid down to lure crocodiles as a nightly tourist attraction. Immediately, a croc lunged at the leopard, which disappeared into the inky undergrowth. While the other lodge guests filed into dinner, I raced back to my room and grabbed a camera, tripod and flash in the hope that the leopard would be tempted to return. Sacrificing my dinner paid off, because eventually the leopard emerged again and I got my shots.

This is an example of a unique picture which has great appeal as a single shot with an extended caption in newspapers and general interest magazines, as well as the natural history press. An Australian magazine ran it as a double-page spread and billed it as Paws and Jaws!

Nikon F4 camera, Nikkor 80-200mm lens, Nikon SB24 flash, Kodachrome 200 film.

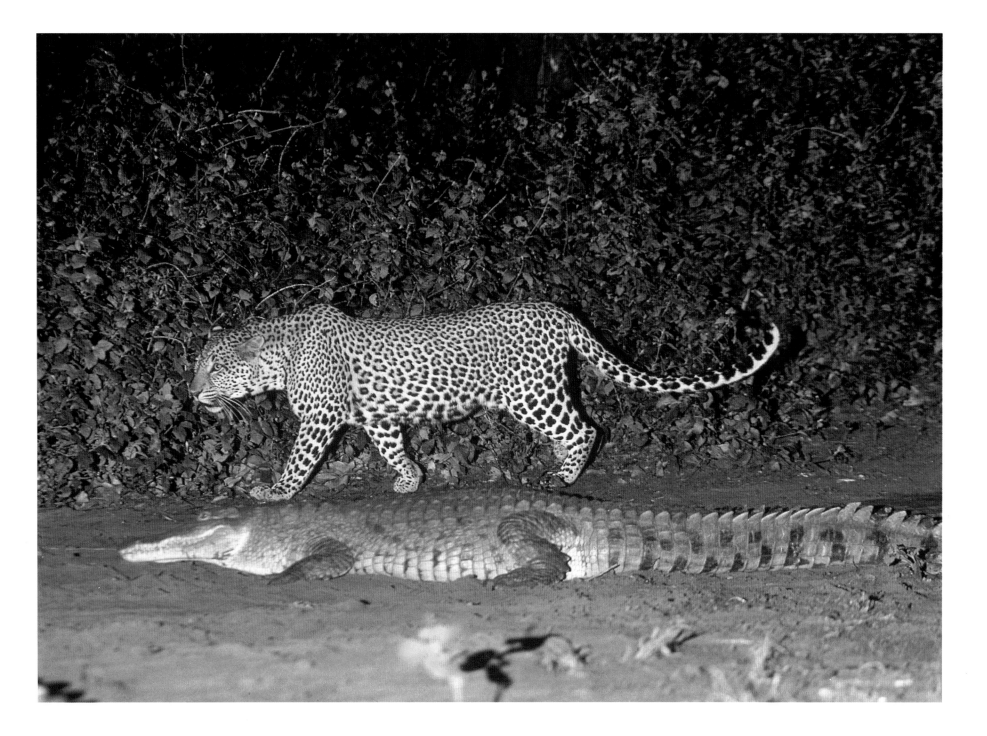

Paws and Jaws

Heather Angel

STILL LIFE: FROG ON LILY PAD

I have always had a great passion for frogs; indeed, my logo depicts a design based on a shot I took of a Costa Rican flying frog, which is a consistent good seller. Among my all-time best sellers is this photograph of a frog resting on a lily pad taken in my Surrey garden pond. It is one of those classically simple—and timeless— images that has immediate appeal to young and old alike.

Throughout the summer I had inspected the pond early each morning, removing any floating debris, yellow pads or spent flowers in preparation for photography of emerging dragonflies alighting on water lily flowers. This seemingly unproductive task paid dividends as I was able to frame the fog and lily pads without any distracting elements, and with plenty of space to allow cropping to either a vertical (for covers) or a horizontal image (for spreads).

Hasselblad 500 C/M camera, Sonnar 250mm lens, Ektachrome 100 film.

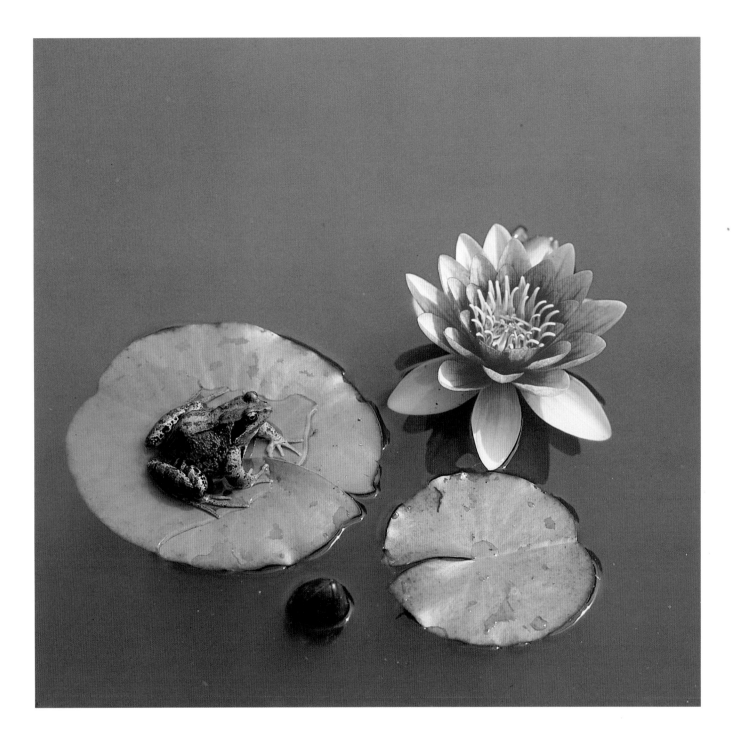

STILL LIFE: FROG ON LILY PAD

Heather Angel

Anthony Bannister
SOUTH AFRICA

• • • • • • • • • • • • • • • • • • •

My loves of wildlife and photography arose from two separate but profound influences in my early life: a childhood spent in rural England and, after my family emigrated to South Africa, a kindly uncle who took me to the Kruger National Park and allowed me to use his Leica camera.

From my home in the beautiful Natal midlands of South Africa, I regularly travel to African countries and elsewhere in the world, undertaking photographic assignments for a wide range of clients, from environmental organizations to movie studios. Although much of my work does not involve wildlife photography, I

FIGHTING JACKALS

The western coast of Namibia is a desolate place; a thousand unbroken miles of desert shore pounded by cold and powerful Atlantic breakers. There is collusion between the cold ocean and the hot desert that shrouds the Namib in thick fog for much of the time and brings howling, sand blasting gales at others. Walking those beaches, I always find it easy to imagine the desperation of shipwreck victims stranded there, with only mocking mirages and pink dunes extending inland for a hundred miles—without fresh water, without hope. The Namib desert is a harsh and unforgiving place and its Skeleton Coast aptly named.

I time most of my visits to the Skeleton Coast to coincide with the spectacular annual breeding of Cape fur seals. Each year nearly half a million of these magnificent mammals gather in great and noisy colonies to drop their pups and rear them on fish caught in the rich offshore waters. It must rank as one of Africa's greatest spectacles.

Black-backed jackals are a permanent feature of the Skeleton Coast and continually scavenge the shore. They're bold, and patrol the tightly packed colonies of lumbering seals with impunity, making a living on pups injured by jostling adults, or temporarily unguarded whilst their mothers are away fishing at sea. The jackals continually challenge and fight each other according to the prevailing hierarchy, signaling dominance with their rapidly wagging tails. This photograph was of just such an occasion that occurred on one of those rare mornings without wind or fog, as the jackals fought briefly over the carcass of a seal pup.

Another strong memory the photograph recalls for me is of having to chase a pair of black-backed jackals down the fog-bound beach that night in order to recover my leather sandals, scavenged from my bedside.

Nikon F3 camera, Nikkor 400mm lens, Kodachrome 64 film.

28

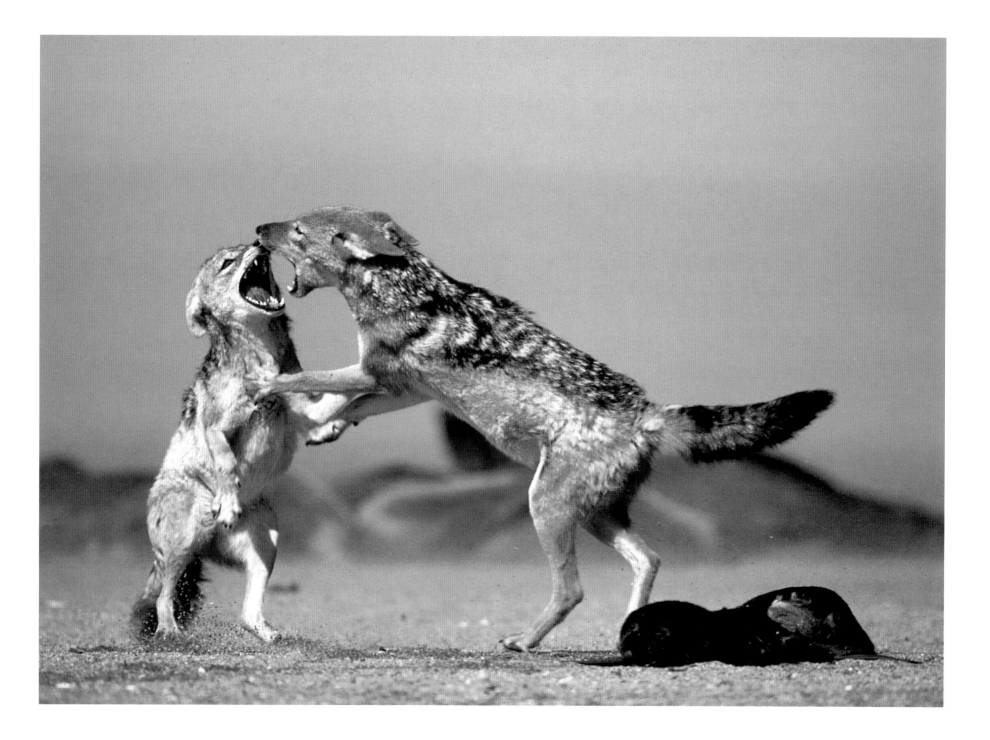

FIGHTING JACKALS

Anthony Bannister

RED LECHWE

I know of no greater thrill than photographing Africa and its wildlife from a light aircraft. Given good weather, a competent bush pilot and the door off the plane, it's an unbeatable experience. I took this photograph over the famous Okavango Delta in Botswana whilst on assignment to shoot advertising photography for an international safari company.

Early morning found our Cessna 210 bouncing down a remote bush strip and gently lifting into the cool, dense morning air. This is my favorite time for aerial photography.

The previous evening around the campfire, I'd carefully briefed my pilot on the shots I wanted. Red lechwe typify the Okavango and now, at a thousand feet, with the Okavango's vast network of flood plains and islands stretched to the horizon, we soon located a large herd grazing. Because a fixed-wing aircraft travels in more or less a straight line over the photographic target, all decisions as to your altitude, angle of approach, and position at the moment of exposure must be made well before commencing the final run to target.

The photograph here is one of about ten motor-drive frames I shot as we flew across the flood plain, the lechwe characteristically heading for the open at the sound of our approaching aircraft (as they do at any hint of danger). A moment later, we were a thousand feet away.

Nikon F4 camera, Nikkor 35mm lens, Fujichrome Velvia film.

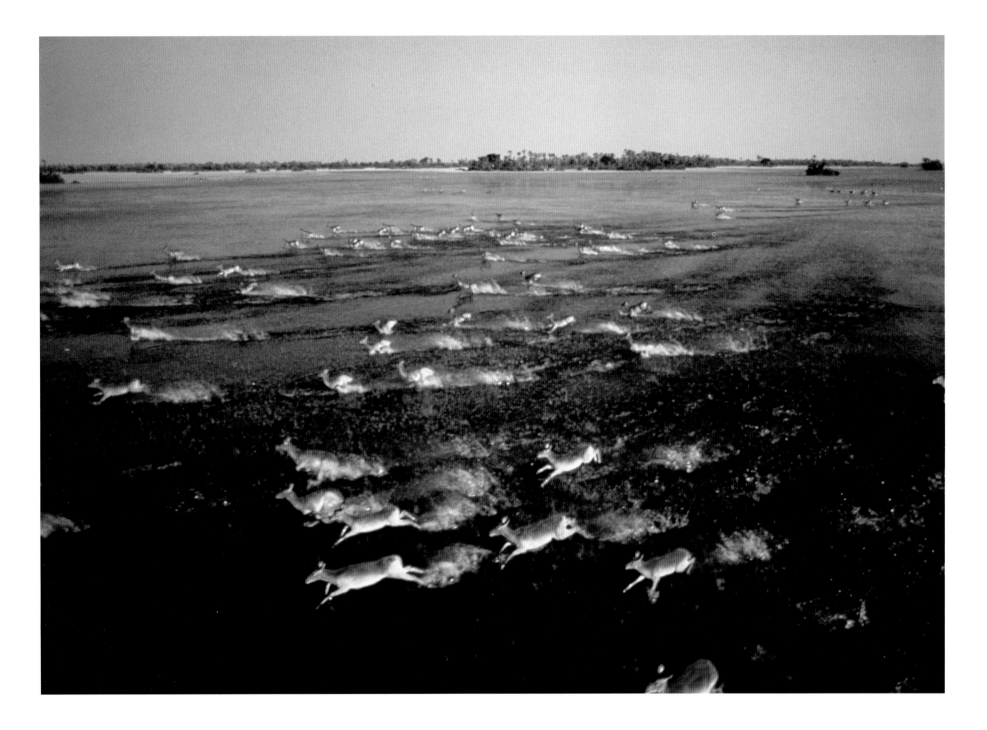

RED LECHWE

Anthony Bannister

FLAP-NECKED CHAMELEON WITH GRASSHOPPER

Wildlife close-ups are a special favorite of mine, and I especially enjoy the otherwise hidden worlds that magnified images so often reveal.

I took this picture along the Kruger Park's famous Lower Sabie road, where often you can see all of the "big five" in a single day. It was a scorching February afternoon, and as I waited for a large herd of elephant to cross ahead of me, I became aware of the chameleon slowly making its way across the boiling hot road surface, walking on the tips of its claws in an attempt to escape the intense heat.

Once the elephants were out of sight, I got out of my car and lay on the road, camera in hand, slowly edging toward the chameleon on knees and elbows, by now feeling the full effect of the burning asphalt. It was only upon finally focusing the lens that I noticed the tiny grasshopper peeping at me over the chameleon's back. It had obviously found its own solution to crossing the hot road.

Nikon F3 camera, Micro-Nikkor 200mm lens, Kodachrome 64 film.

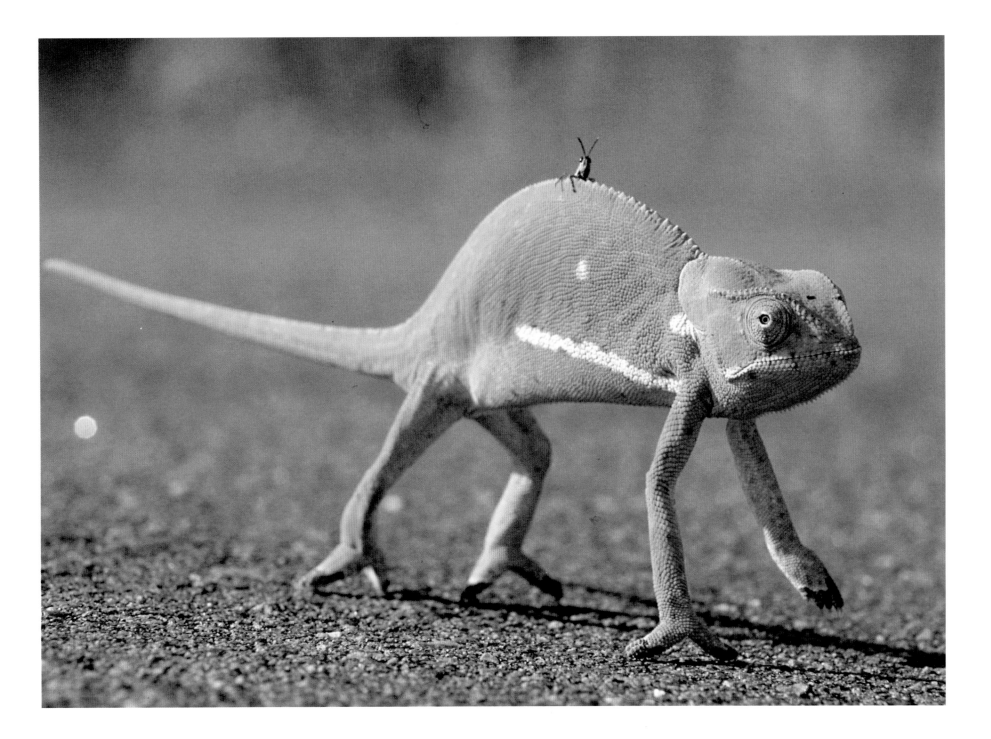

FLAP-NECKED CHAMELEON WITH GRASSHOPPER

Anthony Bannister

Erwin & Peggy Bauer
UNITED STATES

● ● ● ● ● ● ● ● ● ● ● ● ● ● ● ●

*It is difficult—no, impossible—to
imagine any way of life more fulfilling
than ours. Photographing wildlife and
wilderness has taken us to many of the
most magnificent scenes left on earth.
For one of us, the idyll began during
boyhood, by simply taking pictures of
caged animals at the Cincinnati Zoo
with a pinhole box camera. For the
other, it began when we met during a
voyage to the Seychelles Islands a
quarter of a century ago. Soon after
that, we were married and have since
been inseparable.*

*From time to time, we have
photographed such other activities as
trekking in Kashmir, white-water
rafting, trout fishing, and climbing
Mount Kenya, but none of these has
ever matched the thrill of bringing
wild creatures into sharp focus in the
viewfinders of our cameras.*

HALFTAIL IN THE DELUGE

For a memorable six weeks, often from daybreak until dusk, we tracked this female African leopard and her cub on the edge of Kenya's Masai Mara plain. We called her Halftail because the tip of her tail was missing after a losing encounter with baboons.

We photographed Halftail stalking and sleeping, playing, nursing and finally weaning the cub as Kenya's winter dry season drew to an end. The first showers were changing a brittle brown landscape to bright green as we sat with driver-guide Joseph Gichanga, watching the sleek, spotted animal crouch tense and motionless in the crown of a thorntree, her yellow eyes on a herd of impalas that slowly approached. We knew that Halftail had not eaten for two days.

Also approaching, rapidly, was an ugly thunderstorm. The sky to the south was black, illuminated only by flashes of lightning. Because heavy rains can quickly turn this area into an impassable quagmire, we risked being marooned here should we wait. But we elected to stay because the prospect of photographing Halftail at close range, seizing prey, was too inviting to ignore. It looked like a sure thing.

The always nervous impalas came slowly closer. At a moment when all heads were down to nibble on the new grass, Halftail dropped from the tree and dissolved into the grass below. Our fingers were white on shutter buttons—and then the sky opened up.

During a lifetime spent roaming the outdoors, no storm has ever struck us so suddenly and so savagely. In an instant we were drenched by a sheet of cold water. As we scrambled to close the vehicle's roof hatches and cover camera gear, the impalas bounded away. Somehow, Peggy had the great presence of mind to keep shooting pictures of Halftail through the downpour. But these pictures were completely forgotten until, home again in Montana, we projected slides of the defeated, dejected, thoroughly soaked leopard onto a screen. Of all our leopard images, this one of drenched Halftail is our favorite.

Canon EOS-1 camera, 400mm lens, Kodachrome 200 film.

34

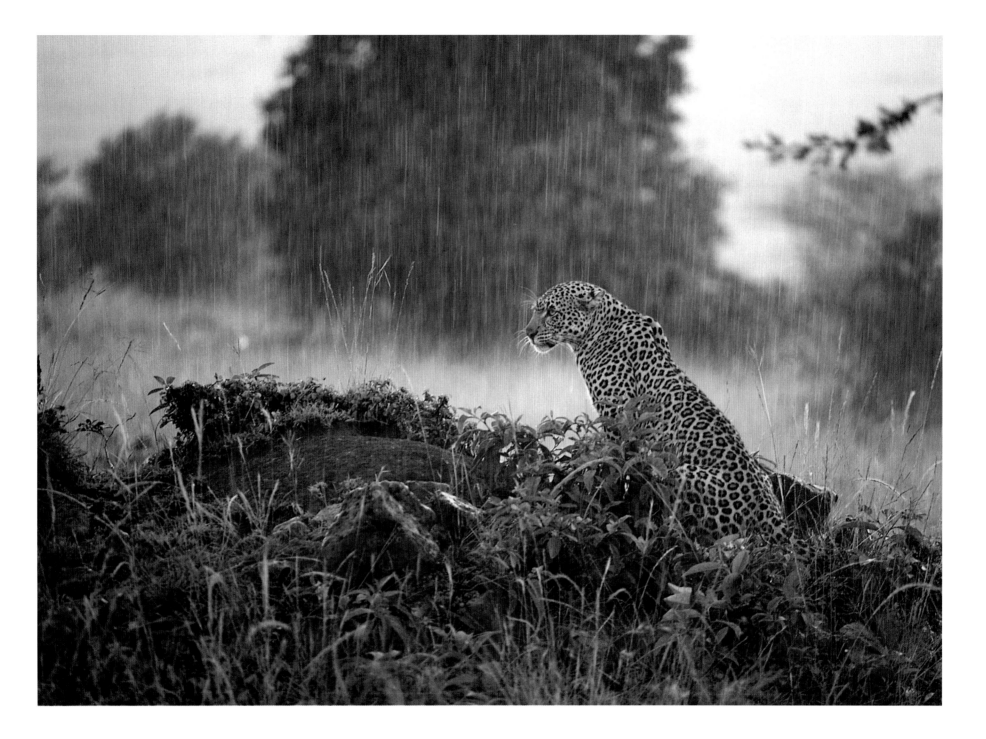

HALFTAIL IN THE DELUGE

Erwin and Peggy Bauer

Torres del Paine Guanaco

One great advantage of wildlife photography over any other vocation—or avocation—beyond the challenge and excitement, is that it lures cameramen to the most exquisite scenes on earth. One such surreal place is Torres del Paine National Park, where the Andes Mountains abruptly end in extreme southern Chile.

We visited Torres almost as an afterthought. After too little physical activity aboard a ship in Antarctica, our first landfall in South America was Punta Arenas, an outpost on the Strait of Magellan, not far from the bottom of the continent. We rented a car and drove northward on a jarring, washboard surface toward Torres, 150 miles away.

Our plan was to shoulder backpacks containing cameras and to climb the steep trails. We found flocks of rheas near the trail head, and judging from the scat and fresh footprints, we just missed meeting a puma, the same species that often wanders through our backyard 6000 miles away in Montana. The higher we hiked, the more guanacos we found in high meadows. Guanacos are smaller, more agile and graceful New World relatives of Old World camels.

Some successful wildlife photos are the result of meticulous planning. Pure good luck accounts for others. This photo of the guanaco, with the awesome towers of Paine looming behind, practically composed itself. Following a shower when we sat down to rest and savor the stunning sight, a single guanaco walked right into the scene.

Nikon F4 camera, 800-200mm lens, Kodachrome 64 film.

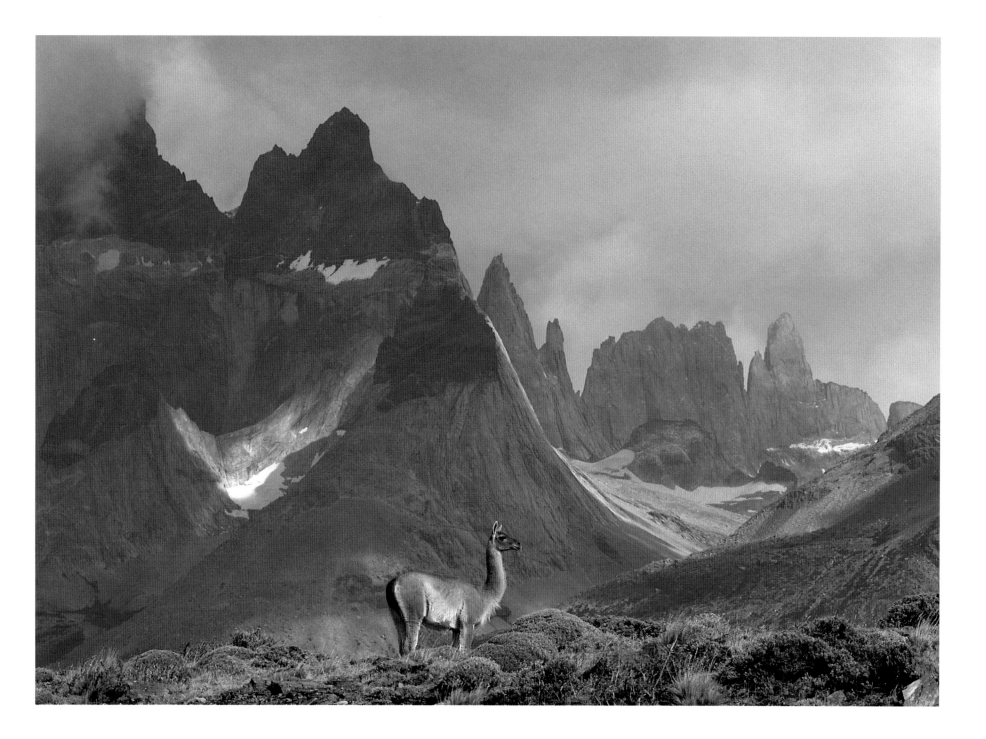

TORRES DEL PAINE GUANACO

Erwin and Peggy Bauer

Courting Bears at Katmai

Though we have often filmed brown and grizzly bears in Alaska and Yellowstone, we know that finding photographable bruins isn't easy. For this venture we opted to go in July, when many bears roam remote ocean beaches of Katmai National Park to dig clams and catch spawning salmon. For that we chartered a small boat, the M/V Waters, a research vessel once used by the National Geographic Society. We cruised Shelikof Strait, which separates Kodiak Island from Katmai, watching for bears. Once seen, we would go ashore in a smaller craft to photograph them.

This strategy was not without risk. The great variation here between high and low tides exposes vast flats over which the bears forage. To stand exposed and unarmed, alone on such a flat, among carnivores that might weigh 800 or 900 pounds, was enough to make this camera couple liquid in the knees for a while. After several days of shooting the clam-diggers without incident, fear disappeared and we probably became too relaxed for our own good.

One morning we saw a medium-sized bear at Hallo Bay, but the instant our landing boat scraped ashore, the animal ran away. Puzzled, we looked around and saw the reason. Two much larger bears were strolling— no, hurrying—toward us.

Fortunately these bears, a male and a female, were lovers rather than fighters, although what followed more resembled fighting. For an hour or more we focused on the courting pair. Between bouts of nuzzling, posturing, biting and growling, the two would stand on hind legs and box. Film ran through our 35mm SLRs as fast as the motor drives would advance it, revealing the roughest courtship we have ever seen.

Canon EOS-1 camera, 600mm lens, Kodachrome 200 film.

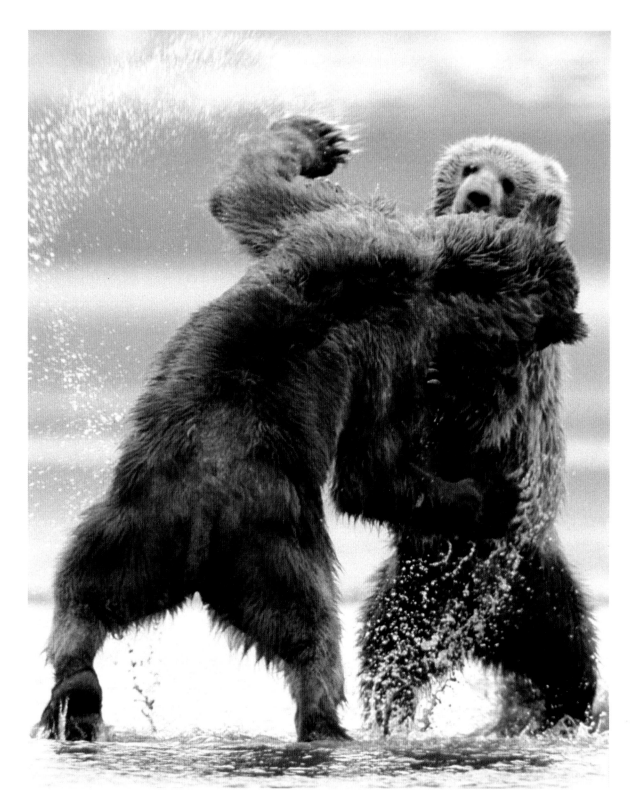

COURTING BEARS AT KATMAI

Erwin and Peggy Bauer

Jim Brandenburg
UNITED STATES

• • • • • • • • • • • • • • • • • • • •

I am a hunter. I am a storyteller. I am an artist. But most of all, I am a hunter living in the late 20th Century.

For most of my life I have been coming to grips with the fact that I am closer genetically to a wild and primitive man than to a fashionably clothed, computer-wielding urbanite.

I was blessed by being born into a family that allowed my day dreaming during my growing-up years. I believe now those wanderings that began in the mind and eventually led to the fields and the woods triggered what I

ARCTIC WOLF SITTING ON ICEBERG

Two things crossed my frozen mind as I crawled toward the leader of the pack: *This could be the greatest photograph I've ever made* and *It is impossible to sneak up on a wolf.*

I was on Ellesmere Island in the high Canadian Arctic, 500 miles from the North Pole. It was March, and the sun was just returning to the north end of our planet, rising above the horizon for only a couple of precious hours a day. For the rest of the 24 hours, the light was an icy blue-black, befitting the sometimes -70°(F) temperature.

My assignment for *National Geographic* was to photograph a dog sled expedition to the North Pole. The encounter with this pack of arctic wolves not only diverted my attention from my designated assignment (which I later learned much distressed my editors at the magazine), but also changed my life.

In the impossibly cold arctic air I saw before me a potential photograph that made me boil with anxiety. I have never been so rattled before or since while making a photograph. Fumbling with two winterized cameras, I lay prone on the ice, shaking with fear and wind chill while I frantically shot off several rolls of film. In my panic, I accidentally opened up the back of one camera before unwinding. Another roll snapped from the cold, while most of the other frames of the remaining attempts were soft from the 1/30th of a second exposure. Two frames survived. This is one.

Nikon F3 camera, 300mm lens, Kodachrome 64 film.

40

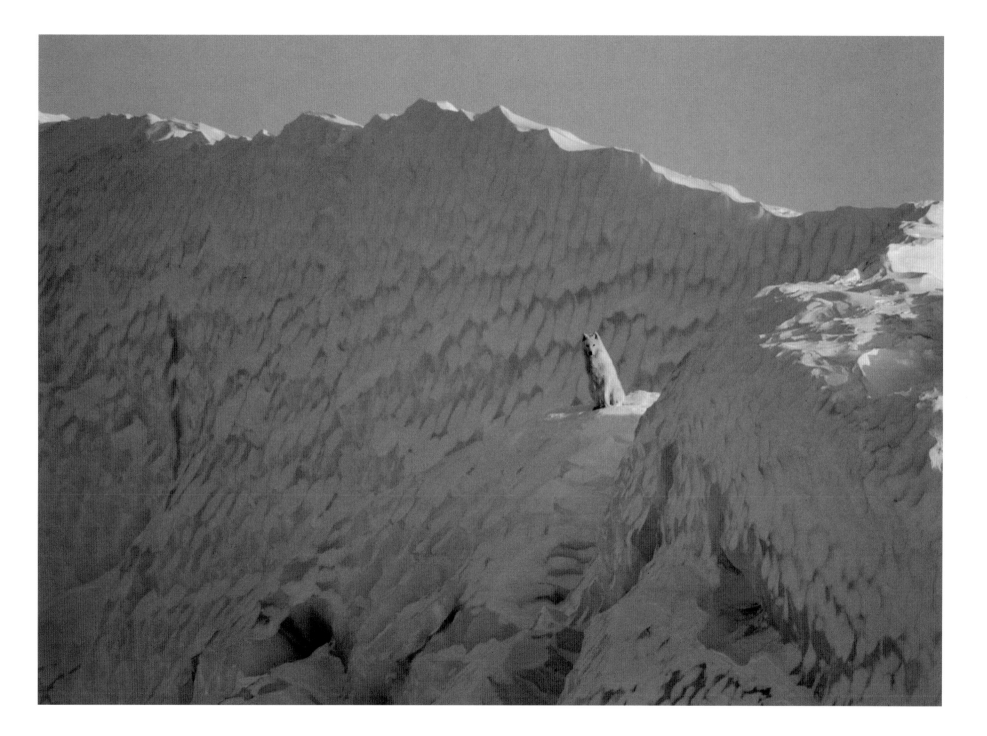

ARCTIC WOLF SITTING ON ICEBERG

Jim Brandenburg

consider very primal, basic appetites
within me—especially that hunting,
questing side.

Exchanging my gun for the camera, I
carry out an age-old ritual of tracking
elusive creatures like the wolf or lynx
through the woods.

My beat today is not the world, but
my immediate territory. I find
wonderment and depth when I can
penetrate the mystery of nature on a
land that I am close and intimate
with. To know a land and watch its
parts grow and die over the years gives
me a comfort and a sense of purpose
that I have never felt in far-off lands.
Is it possible, as our ancestors belived,
that one can only truly comprehend
land that can be walked to?

The hunter in me can nearly hike
blindfolded along my cherished trails.
The storyteller in me has a more
complex fabric to weave my tale. And
finally, the artist in me has in this
private space a constant source of quiet
inspiration.

TERN OVER A PRAIRIE SLOUGH

As difficult and as complicated as my arctic wolf on an iceberg photograph was, this prairie photograph was incredibly casual and uneventful in its making. In fact, nearly 20 years later, I am still perplexed as to why the scene didn't make a deeper first impression upon me as I sat in my Subaru in the normally unphotographable brilliant and contrasty noonday sun.

I was having lunch on a lonely North Dakota gravel road when I glanced from my window and noticed a sooty tern sweeping back and forth across a prairie wetland. I do remember thinking to myself, "I'm probably wasting good film," as I grabbed my camera.

I was working for The Nature Conservancy, documenting prairies, a landscape that was and is very dear to me. This was my homeland, where as a boy I learned to make photographs. In those days, opening up rolls of freshly processed buttery-smelling Kodachrome was always exciting after my mini-expeditions to the grasslands. Finding this treasure, I realized my early-learned subconscious prairie language was still speaking to me.

Nikon F2 camera, Novaflex 640mm lens, Kodachrome 64 film.

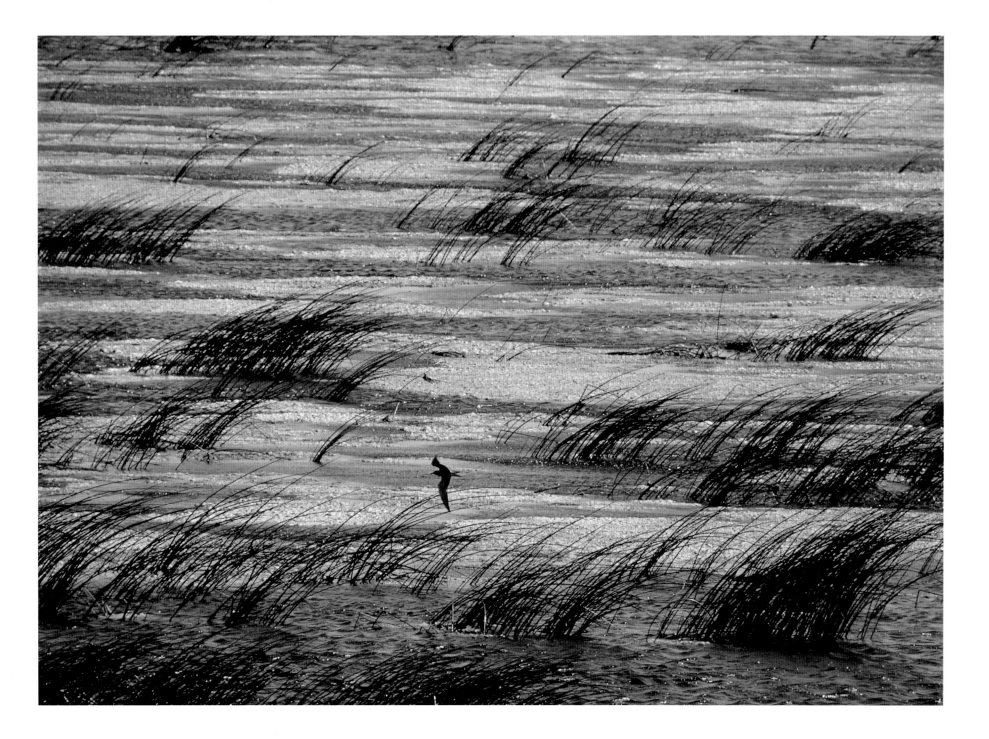

TERN OVER A PRAIRIE SLOUGH

Jim Brandenburg

Oryx on Namib Desert

Even though this photograph was made in far-off Africa, I resurrected my old prairie instincts again and was drawn toward the starkly simple statement this photograph makes.

I was on assignment for *National Geographic*, doing a story on Namibia in southern Africa. My job was to photograph the people engaged in a racial war. Once again, I was distracted by the natural history of the area. Instead of spending my time in the war zones, I was fascinated by another struggle—that of the wildlife of the Namib Desert, particularly the oryx.

Early on in the coverage I had a preconceived idea of an image of this almost mythical, unicornlike wandering creature. It would be a lonely picture. It would have dramatic lighting. Its setting would be in the tallest sand dunes in the world. Three weeks later, after countless attempts with three steps forward, sliding two back, my sand-filled cameras captured the scene of my mind. I think this was the only time in my career a preconceived photograph matched my vision.

Nikon F3 camera, 80-200mm lens, Kodachrome 64 film.

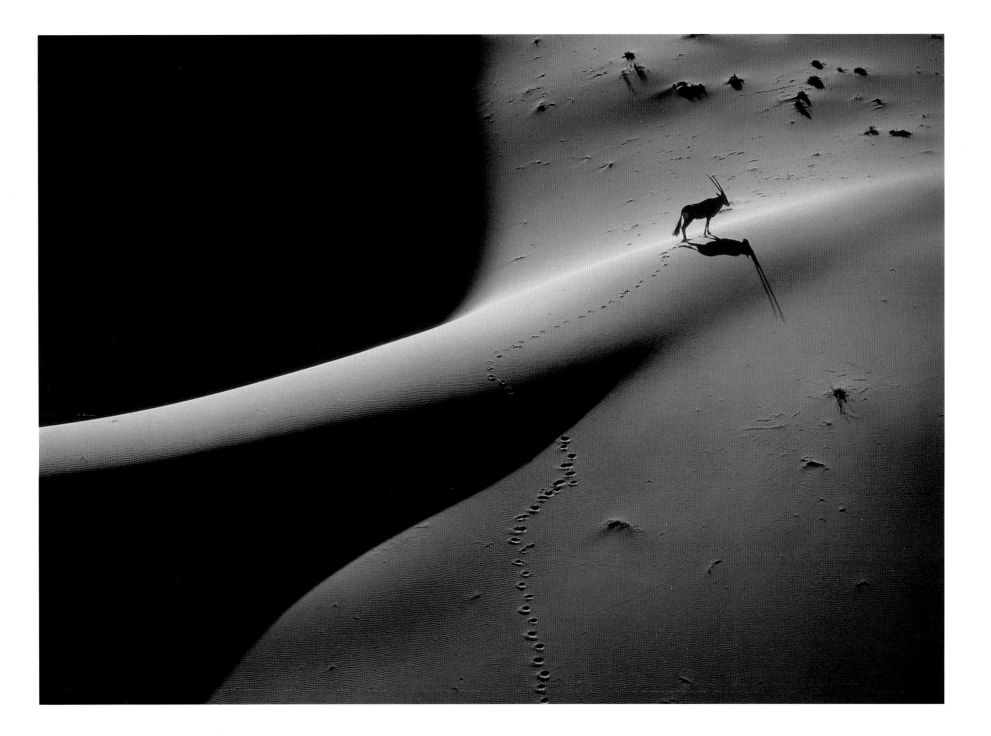

ORYX ON NAMIB DESERT

Jim Brandenburg

Fred Bruemmer
CANADA

The Arctic has become my realm. I love its space, its wildness, the harsh grandeur of the north, the magnificence of its animals, superbly adapted to an often lethal climate, and I try to convey some of this love and admiration in my pictures.

WADING AMONG THE WALRUSES

Walruses are sociable animals; they love togetherness and they migrate en masse. In an Arctic sea speckled with empty ice floes, so many will pile onto one floe that it nearly sinks beneath their weight. And those that do not migrate, mainly males, sleep in their thousands on a favorite cliff-backed beach that is packed with a solid layer of wall-to-wall walruses.

I spent some summer weeks near one such hauling-out beach in Alaska, part of a 30-year effort (that continues) to study and photograph the lives of all the world's pinniped species.

At the end of the season, I had many pages of field notes and too many pictures of sleeping walruses. "What would happen," I asked biologist friends in Alaska the following year, "if I joined walruses in the shallow water near their hauling-out beach?" Opinions diverged: a few thought the walruses would attack; most said they would flee.

Back at the walrus beach, I put on hip waders, eased into the water behind a shielding rock, and crept cautiously toward a group of walruses lolling in the shallows 30 feet away. It took the bulls a while to realize I was there and that I wasn't a fellow walrus. They stared at me with bloodshot eyes, baffled and affronted like elderly club men who have been disturbed, wheezed and harrumphed, and then swam closer for a better look. I backed away, slipped and moved abruptly, and in an instant, the water was aswirl with rushing, fleeing walruses.

Weeks passed, the walruses became habituated to my presence, fear changed to indifference, and I could watch and photograph them in the water without disturbing them.

Nikon F3 camera, Nikkor 135mm lens, Kodachrome 64 film.

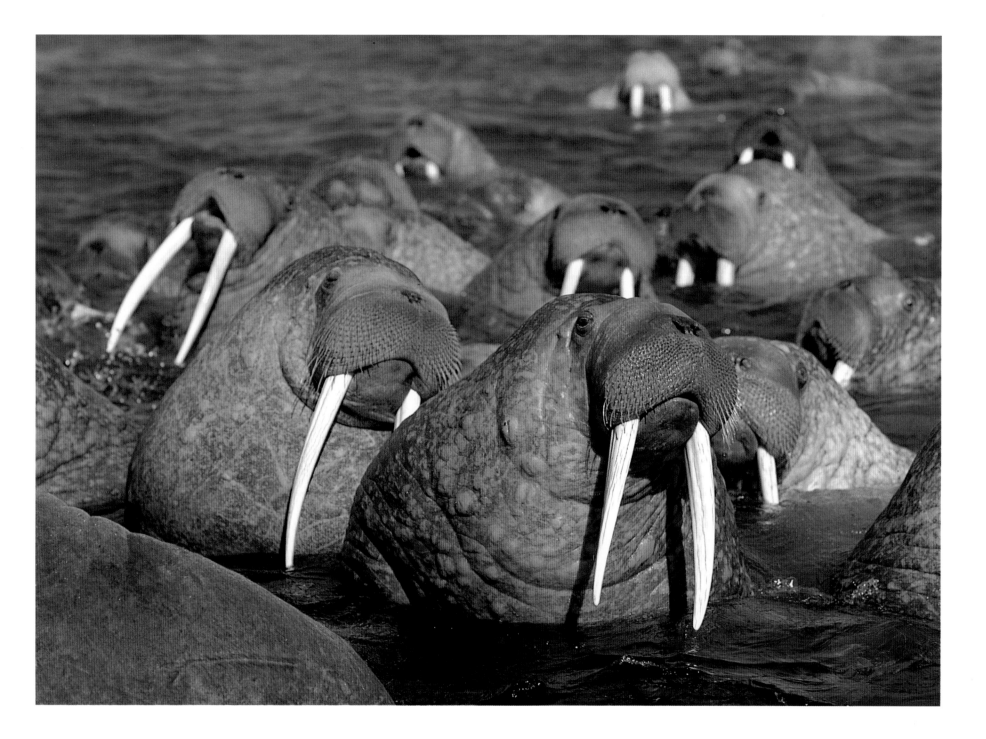

WADING AMONG THE WALRUSES

Fred Bruemmer

Harp Seal Pups in the Eyes of the World

These are the dark appealing eyes that moved a world to pity. I saw them first in the early 1960s, when I went with Canadian scientists to the vast pack ice fields off Newfoundland and Labrador to tag newborn harp seal pups. We jumped from floe to floe, clamped tags to flippers and, whenever time permitted, I took pictures of the pups. They were adorable creatures. Pure white upon snowy beds of white, with large lustrous eyes, they seemed to me like innocence incarnate.

Death followed us. Sealers swarmed across the ice, and within a few days they killed and skinned about 90 percent of the newborn pups.

The next year, the great French magazine *Paris Match* published a three-page article about the seals and the seal hunt, together with a few of my seal pup pictures. That triggered an avalanche of mail, the largest reader response to any article ever printed by this prestigious magazine.

Other magazines picked up the story and the pictures. The first and perhaps greatest crusade of the environmental movement began, its emblem—my seal pup pictures—on myriad posters and placards with the line from the Beatles' song *Let It Be*.

In 1986, a Canadian royal commission found that the hunt of harp seal pups "is widely unacceptable to the public and should not be permitted." In 1987, the hunt was officially ended. In 1989, my harp seal pup picture was among the 51 photographs chosen for the book *Photographs That Changed the World*.

I still go to the ice each March and take more pictures of the newborn pups. They now live in peace. Instead of being confronted by sealers armed with clubs, they now see tourists with cameras, often guided by former sealers.

Nikon F3 camera, Nikkor 55mm lens, Kodachrome 64 film.

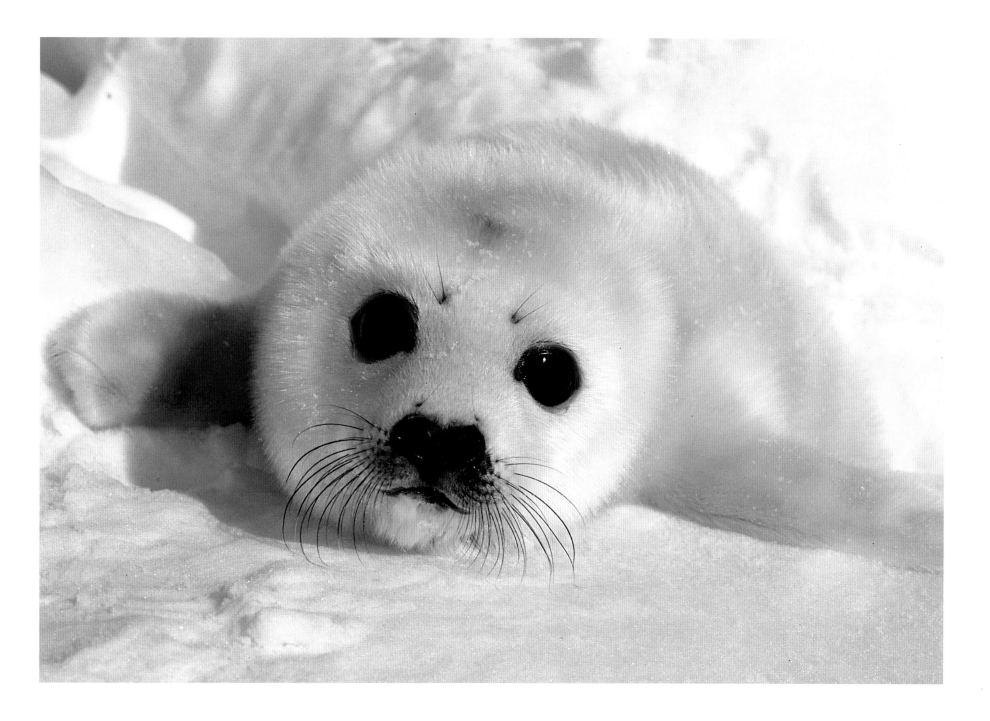

HARP SEAL PUPS IN THE EYES OF THE WORLD

Fred Bruemmer

POLAR BEARS ROMPING IN A STORM

Bears are highly individualistic creatures, full of quirks and idiosyncrasies. When I began to observe and photograph them 30 years ago, the bears were simply bears, mighty but anonymous. Gradually, over weeks and months, personalities began to emerge and since most of the observed bears, and I, returned year after year in October and November to the Cape Churchill region on the west coast of Hudson Bay, some of the polar bears eventually became well-known acquaintances.

Young male polar bears, usually between four and eight years old and weighing 300 to 700 pounds, love to playfight. These mock battles look ferocious and deadly, but they are as ritualized as a medieval jousting match, and much more civilized, because playing polar bears, despite their awesome power, are extremely careful not to hurt each other.

When the mood is right, the bears romp and wrestle in any weather, even in a howling snowstorm, when this picture was taken. These wrestling matches follow certain patterns, and having watched polar bears for such a long time, I can, to some extent, anticipate action and behavior.

I lived for many years with Inuit (Eskimos), recording their vanishing traditional way of life. Now, with animals, I seek a similar rapport, an understanding of their way of life, and try to express this involvement and empathy in photographs.

Nikon F801 camera, Nikkor 300mm lens with 1.4 teleconverter, Kodachrome 64 film.

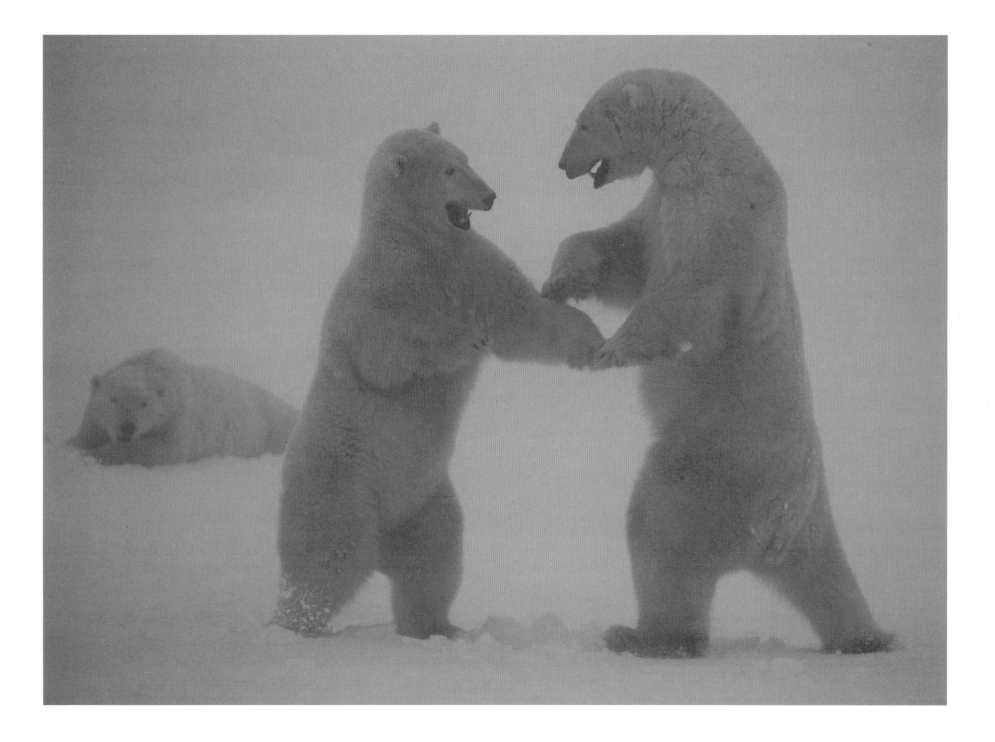

POLAR BEARS ROMPING IN A STORM

Fred Bruemmer

Stephen Dalton
ENGLAND

• • • • • • • • • • • • • • • • •

I am no Marco Polo. Rather than spending months on end living under canvas in steaming rainforests or desiccating deserts in exotic countries, I am quite content to stay close to my doorstep to photograph nature.

I have lived and worked in rainforests and, of course, they are ravishingly beautiful places. But to one who considers natural beauty far more moving and stimulating than almost anything man contrives, I find that operating from home provides fewer reminders of the accelerating destruction of Earth's wild places than working in third world countries.

Although most of my photography is done in the field, there are occasions when I prefer to work in the studio. I have no time for purists who say that all nature photographs should be

CHURCH OWL AT NIGHT

This picture of a barn owl flying into an ornate church tower with a rat for its young was my first serious attempt at high-speed bird photography.

The tower was on a church roof, so the camera and hide had to be set on a platform suspended between two gables. Bees had moved into a ventilator at the only point where ladders could be positioned to climb onto the roof. Thus, an anti-bee outfit was needed every time the ladders were used.

One of the secrets of photographing wild animals with flash is to arrange the lights in such a way that the picture looks as though it is lit with natural daylight, or in this case moonlight. For this scene, the lighting was carefully worked out on a scale model before the flashes were positioned around the roof.

With no reliable means of firing the camera electrically, the shutter had to be opened manually before the owl flew into the tower. A photo-electric trip system triggered the flash as the bird intersected a light beam.

When, after a couple of weeks or so, all the hardware was in position, I was plagued with electronic problems. My high-speed flash gear was very primitive in those days (1970), and kept blowing up…passing aircraft seemingly interfering with the trip system, and moths and bats frequently flying through the beam and firing the flash. Eventually I got the picture.

Leicaflex SLR camera, 50mm lens, Kodachrome 2 film.

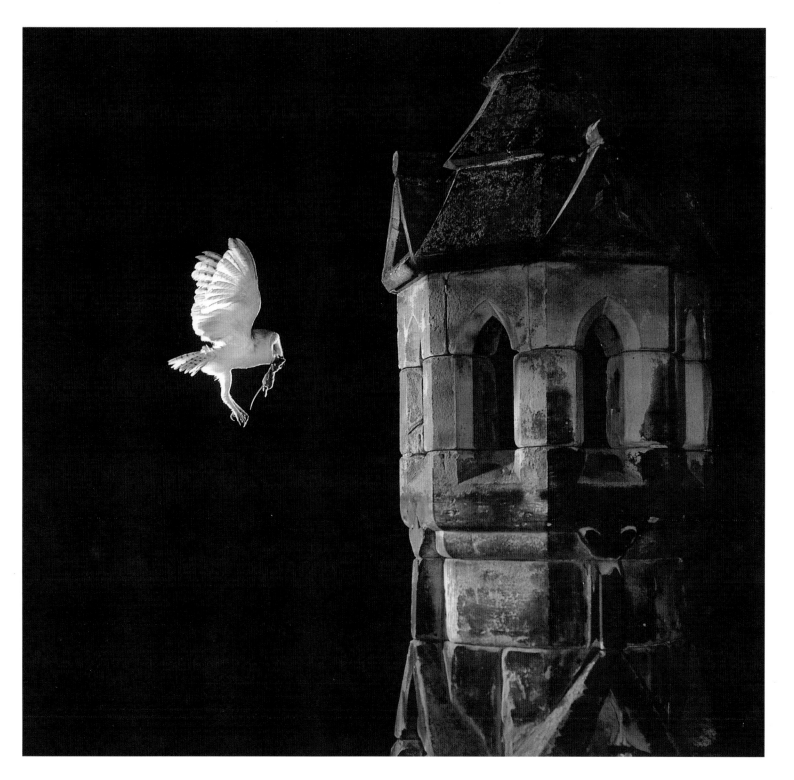

CHURCH OWL AT NIGHT

Stephen Dalton

exposed under the open sky, as a wide range of approaches and techniques need to be employed to show the infinite variety and beauty of life. Some wildlife photography is impossible, impracticable, or just uneconomical to attempt in the field.

But the skills needed for studio photography are very different to those required for field work. The vital thing is to produce results that are indistinguishable from shots taken in the field. The photography has to be performed with consummate sensitivity, where an intimate knowledge of the natural history of the subject, as well as a sound understanding of techniques, is crucial.

These photographs represent the early, mid, and more recent period of my career as a nature photographer. There are other images which I prefer in some ways, but these are among my most memorable subjects, and each is a "best seller."

SWALLOW DRINKING ON THE WING

I often watched the graceful swallows dipping into the fish pond after completing a large circuit of my garden. Sometimes they seemed merely to brush the surface with their beaks; less frequently, they struck the water with an impressive splash. Were they drinking, bathing or catching insects? Perhaps high-speed photography would give me the answer.

First, over a week or so, I masked most of the pond with netting to confine the splashdown to a small area. Then, I gradually erected the photographic equipment.

After a further week or two of tests and adjustments to simulate daylight, everything was working perfectly. At last I could see exactly what was going on. Sometimes a bird approached from a very low angle, skimming gracefully over the surface and scooping water into its beak. Often it seemed to take too much, and would squirt the excess out. Occasionally it approached much more steeply and dived into the water with wings folded. Up to a second later, with a dramatic splash, it would emerge like a jack-in-the-box.

Hasselblad camera, 150mm lens, Ektachrome film.

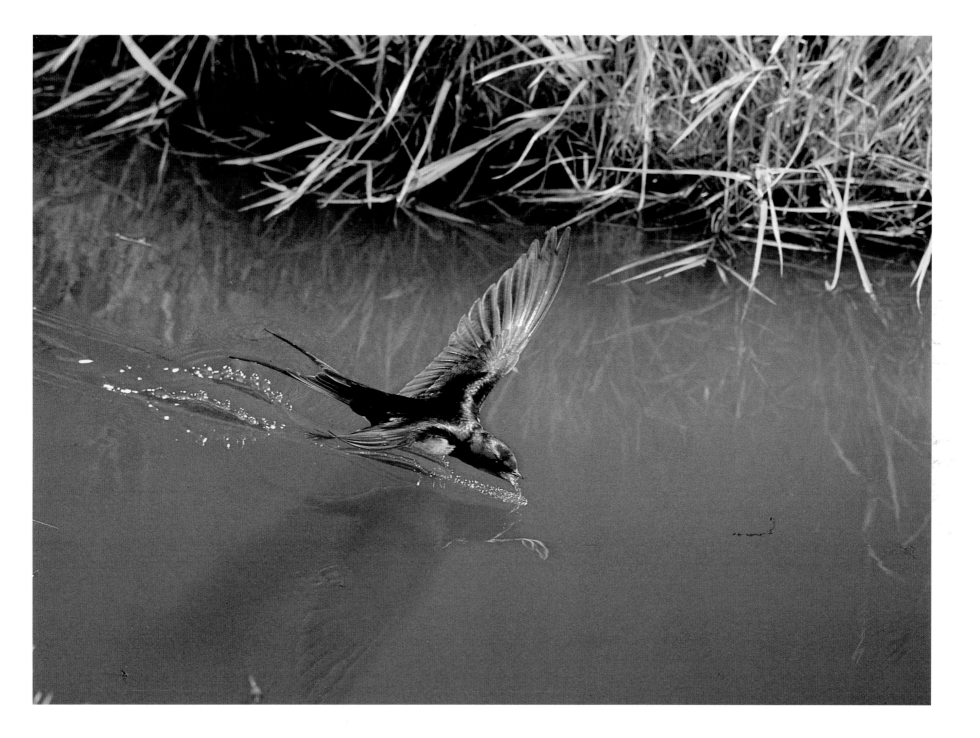

SWALLOW DRINKING ON THE WING

Stephen Dalton

Jesus Lizard Running on Water

In contrast to the previous shots, this running basilisk, or Jesus lizard, was taken in an old Sussex barn converted into a studio.

My goal was to capture this extraordinary prehistoric-looking lizard running over the surface of water, and to evoke its hot, humid rainforest habitat. Like the other two shots, at least three weeks were devoted to its execution.

To engender a feeling of space, a 20-foot-long area was flooded with several inches of water, and suitable South American plants and a rotting trunk were obtained for the background. Seven flash heads illuminated the mini-Amazonian setting, including one to light a blue backdrop to reflect a suggestion of sky into the otherwise "dead" water.

Once the photography started, the trick was to persuade the creature to run sufficiently fast to keep its feet on the surface rather than wading through the water. This was ultimately achieved by recreating the climate the animal inhabits in the wild. Fortunately, there was a spell of very hot sticky weather, so by mid-afternoon, the temperature in the closed barn rose to over 90°(F).

Getting the lizard to run in exactly the right line taxed my patience to the limit. An inch or two out of line and the lizard was out of focus. After countless runs over several days, and much fine tuning, I managed to create the picture I originally envisaged.

Hasselblad camera, 150mm lens, Fujichrome film.

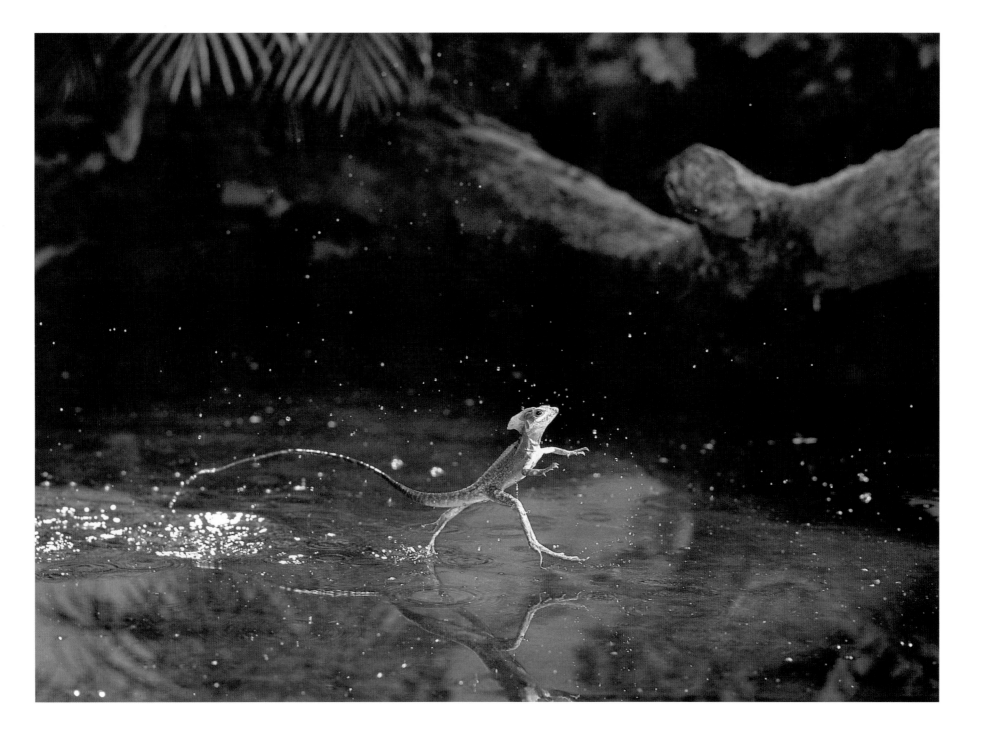

JESUS LIZARD RUNNING ON WATER

Stephen Dalton

Tui De Roy
NEW ZEALAND

• • • • • • • • • • • • • • • • • • • •

I do not see my photography as work: it is simply an excuse to immerse myself deeper into nature. It is the only way I know to share the love, trust and respect I feel for true wildness anywhere on this planet. I do not even consider that I "make" my photographs, but simply "take" them. Fleeting or enduring, the scenes are there in all their splendor and perfection, whether I or anyone else notices. All I do is capture the light of the moment, onto a small scrap of celluloid made sensitive by modern technology.

I spent all of my young years privately probing the secrets of the still wild and

GALAPAGOS HAWK AND VOLCANIC CALDERA

Fernandina Island is one of the most pristine locations in the world. It is perhaps the largest island outside of polar regions where man and his bevy of feral species have thus far made virtually no imprint. With a symmetrical domed summit rising 1500 meters above sea level, and gaping caldera some six kilometers wide and nearly 1000 meters deep, Fernandina is a young and very active volcano, with major eruptions rearranging much of its stark landscape every few years. To visit Fernandina is to take a step back in time, to a place where the land is still being formed and totally unique species still bask in untouched ecological balance.

The endemic Galapagos hawk is at home here, and sees humans so rarely it is utterly fascinated by their presence, sometimes following close overhead or settling nearby for a better look. Under these circumstances, photography becomes a matter of waiting for the moment when the soft sunlight gently caresses this primal setting.

Years may go by between human incursions here, with National Park permits being rarely granted, and usually only to research parties. Over 25 years, I have had the great good fortune of scaling the volcano a dozen times, perhaps more than anyone else. It is a long, arduous climb, and every drop of drinking water must be carried, in addition to food, camping and camera gear.

This photo was taken in 1975, after a gigantic explosion had recently reshaped the entire center of the volcano. Today, after more eruptions, the hawks are still there, but the deep blue mineral lake is not, having been buried by rock avalanches and new lava flows. Fernandina, like a living being, changes her appearance every time I visit her.

Pentax Spotmatic camera, Takumar 24mm lens, Kodachrome 64 film, hand held.

58

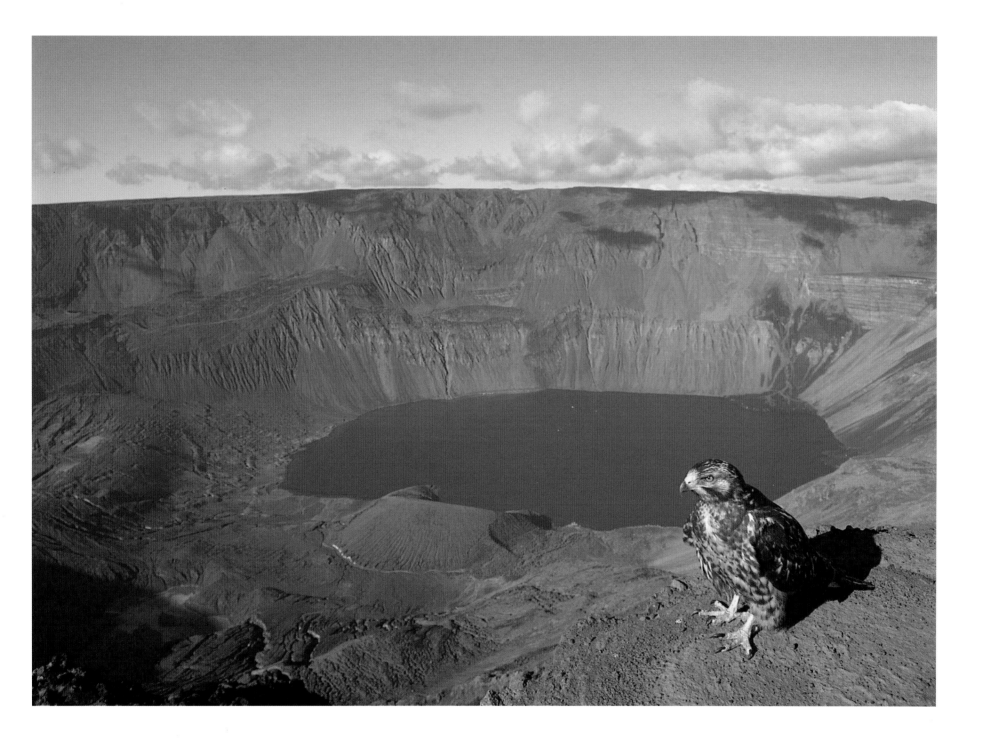

GALAPAGOS HAWK AND VOLCANIC CALDERA

Tui De Roy

largely unknown Galapagos Islands. At 19, I was offered a chance to pursue an education in California. To the surprise of many, I felt my future lay not in academia but rather in exploring and nurturing the profound intimacy and kinship I felt for the magnificent wildlife that surrounded me. A camera served as an incidental field tool while I made ends meet as a tour guide and self-taught naturalist.

That same year I met Les Line, editor of Audubon *magazine, who was visiting the Galapagos and took an interest in my images. This event focused the course of my life, providing me with the justification for the only way of living I could ever imagine.*

MARINE IGUANA AND SALLY-LIGHTFOOT CRAB

This is a classic example of the harmony that exists between much of the Galapagos wildlife. It also illustrates my favorite way of photographing, not premeditating an image, but simply spending time amongst the animals, and through familiarity recognizing how a particular situation might develop.

Marine iguanas are among the most frequently seen Galapagos species, as are sally-lightfoot crabs. These reptiles sprawl in the sun along much of the black lava shorelines, often quasi-lifeless, and described by many visitors as "ugly dragons."

This large Hood Island male, in full breeding colors, had taken a short break from his territorial vigil to plunge into a tidal pool for a few mouthfuls of seaweed. Returning, he was warming up on a boulder before resuming his show-off posture. At that point, a large sally-lightfoot crab came ambling along, picking tiny algal scraps from the damp rock surface. The crab moved slowly on stilted legs while the iguana, without the slightest movement, fixed it with one eye.

I knew what would come next. I had time to position myself so as to align the black face of a cliff as backdrop to the vibrant colors of the two animals. The crab began to carefully pluck minute bits of dead skin from the iguana's back. A moment later, the iguana's attention drawn by a rival male, he stood up, puffed his chest and gave a head-nodding ritualized threat display, while the crab scurried away.

Nikon F2 camera, Nikkor 300mm lens, Kodachrome 64 film, hand held.

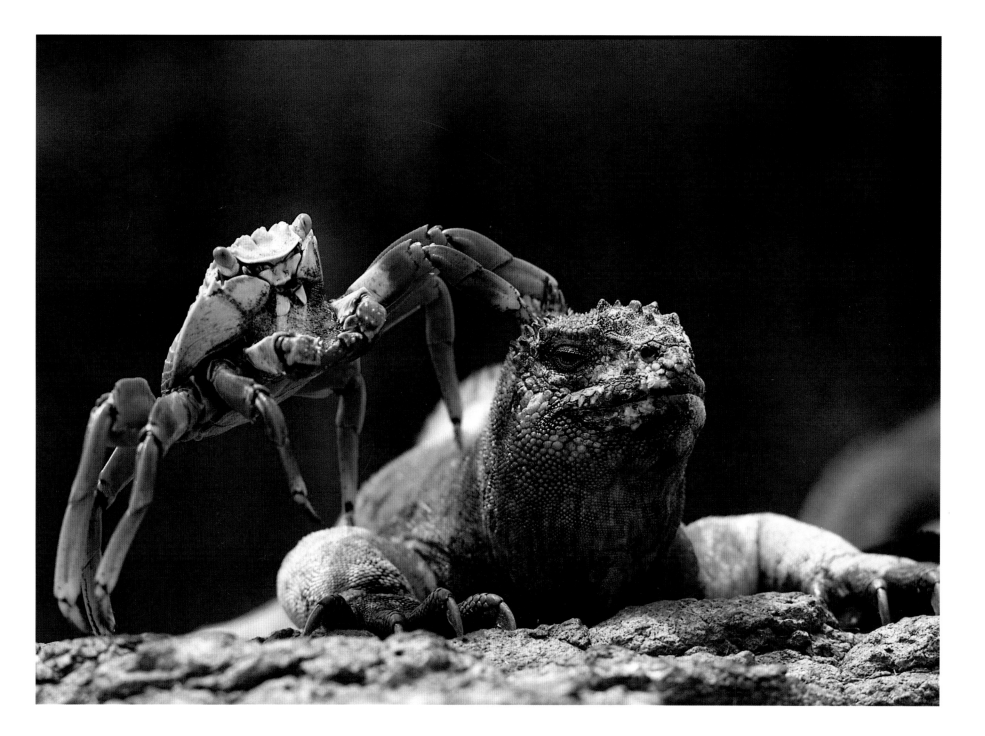

MARINE IGUANA AND SALLY-LIGHTFOOT CRAB

Tui De Roy

GALAPAGOS SEA LION IN UNDERSEA GROTTO

Many years ago, I acquired an underwater camera specifically to try and convey the true feeling of being underwater—the weightlessness, the freedom of movement, the simplicity of color and light I had come to love during my endless days of childhood swimming. Little did I realize how much more difficult this would be than the more frequently seen macro underwater photography taken with well controlled electronic flash. Large undersea wildlife seems to be in perpetual motion, causing blurs and poor framing. Visibility is often a problem, and in depths below 10 meters, where there is no wave turbulence, natural light is dull.

Still, photo or no photo, one of my favorite pastimes has always been swimming and playing with rambunctious young sea lions. I had heard of a beautiful wave-carved grotto on Seymour Island which can be entered only when the swell is down. On this day, all the elements came together perfectly. The sea was calm and clear, the afternoon sun was at the right angle to penetrate through a hole in the roof of the cave, and an adolescent sea lion was splashing and leaping near the entrance.

I shed my SCUBA tank for the freedom of free diving, knowing that sea lions are most intrigued when you try, albeit clumsily, to imitate their underwater antics. I dove down five or six meters and began somersaulting and spiraling in my best sea lion style. The lithe pinniped shot down and circled me several times at high speed. The next time I looked up he was describing a graceful figure eight in the shaft of sun probing the cobalt depth of the cave.

Nikonos V camera, UW-Nikkor 20mm lens, Kodachrome 200 film.

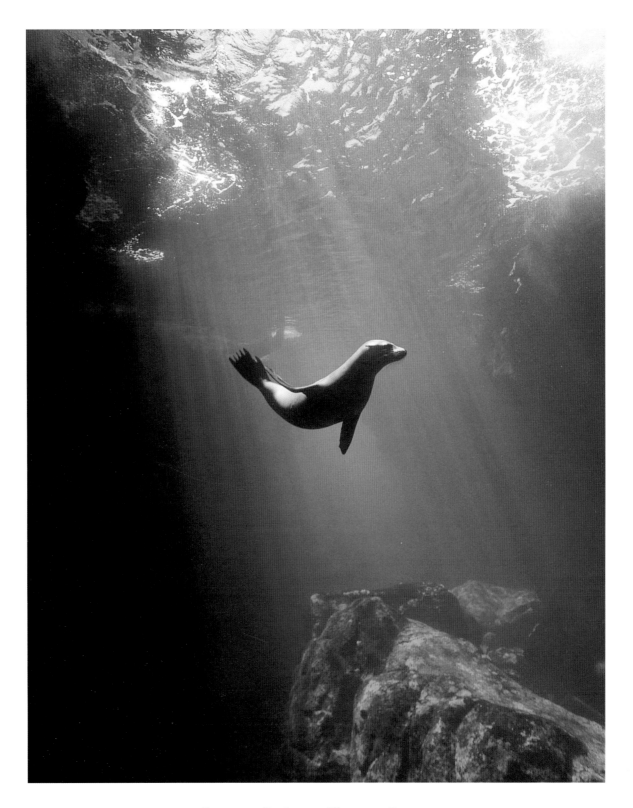

GALAPAGOS SEA LION IN UNDERSEA GROTTO

Tui De Roy

David Doubilet
UNITED STATES

• • • • • • • • • • • • • • • • • • •

There are very few underwater photographers who were photographers first and divers later. The sea demands too much knowledge and too much skill. I had to grow up developing my ability to function in the sea and then my photography.

I began to make pictures underwater when I was 12 years old, in possibly one of the world's worst, least pictur-esque bodies of water—the Atlantic north coast of New Jersey. It is featureless except for the jetties that punctuate the sea every 200 yards or so. The jetties' rocks are covered with carpets of brown mussels and green algae and seaweed. The sea is also brown and green, and on a good day the visibility might be 10 feet. It was a challenge.

But then so was my camera equipment. My first underwater

STINGRAY AND CLOUDS

The stingrays of Grand Cayman are the result of years of feeding by fishermen who cleaned their catches in the calm waters of the Sand Bar in North Sound. In the last few years, dive operators have taken over the feeding. The stingrays—now about 200 of them in two locations—have become a major diving attraction. Almost every calm day nearly 1000 snorkelers and SCUBA divers swim with them. But their time with the rays is short. I like to spend all day with them, watching the light shift over the white sandy bottom.

Rays do not swim; they "fly." Here, the clear sea and the Caribbean clouds come together. A perfect combination of half under and half over.

Nikon F4 camera in Aquatica 4N housing, 18mm lens, Kodachrome 64 film.

64

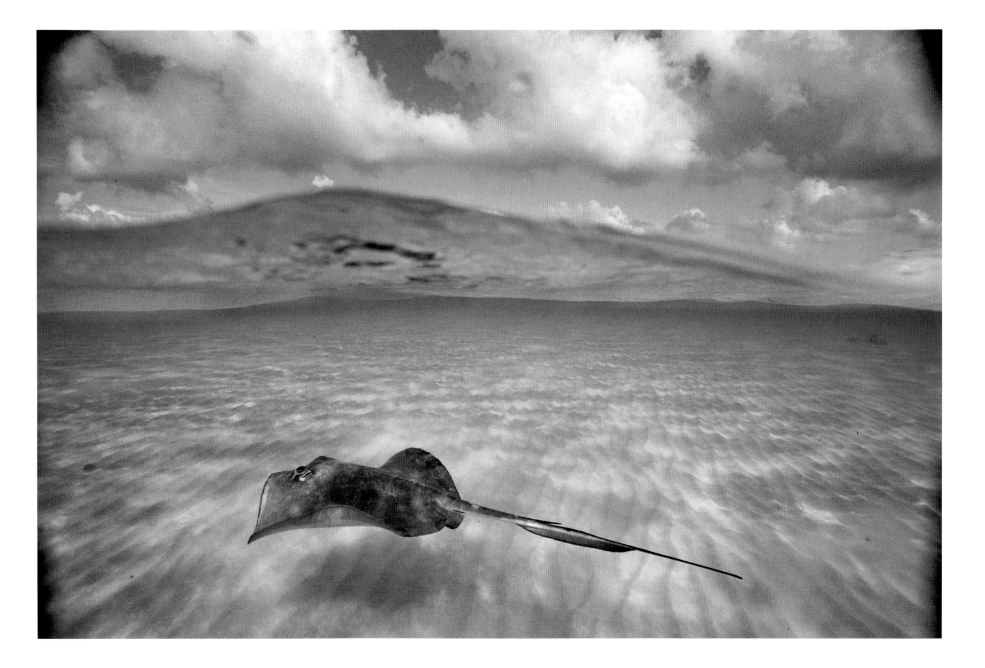

STINGRAY AND CLOUDS

David Doubilet

camera was a Brownie Hawkeye in an anesthesiologist's breathing bag that my father brought home from the hospital. The pictures were horrible.

Later I acquired a Lewis Photo Marine aluminum camera housing for my pre-war Leica. It had the choice of focus or f-stop, but not both. To keep water out, I would pressurize it with a bicycle pump.

Underwater photography is a constant battle with equipment. Making pictures in the sea requires the most sophisticated wide-angle and micro lenses. In the early days (the late 1950s), none of these were available. I had a Seahawk aluminum housing that was made by the great pioneering underwater photographer Jerry Greenberg, then I graduated (really, it was my high school graduation present) to a Rollieflex in a Rolliemarine housing. I could see through it. I could compose. I could change exposure. It had two flashes that required two #5 flash bulbs for each picture. The Rolliemarine could not shoot anything smaller than a tennis ball nor larger than a bread box.

The breakthrough came with the invention and production of the Ocean Eye housing, invented by National Geographic *hero*

CLOWNFISH AND ANEMONE

At the edge of Mine Bay, at the east end of Papua New Guinea, an anemone closes up in the growing darkness. The red velvetlike outer skin enfolds the stinging tentacles along with the clownfish as they seek a place for the night.

The clownfish have a complex commensal relationship with the sea anemone. However, together they form one of the great visual treats of an Indo-Pacific coral reef.

Nikon F3 camera in Aquatica housing, Nikkor 28mm lens, two Sea & Sea YS strobes, Kodachrome 64 film.

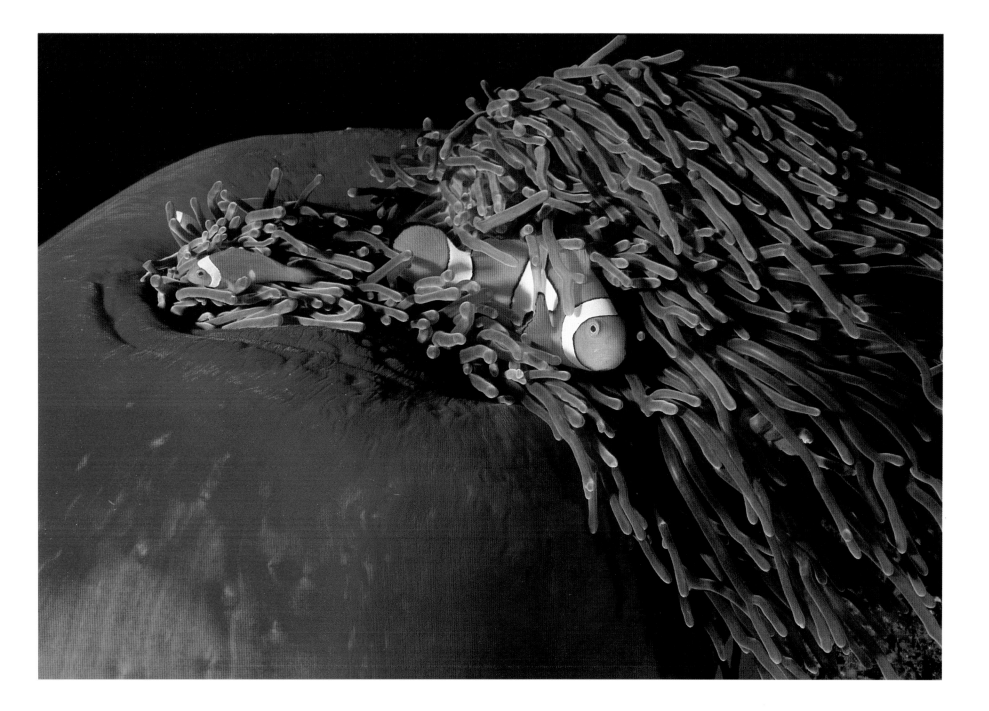

CLOWNFISH AND ANEMONE

David Doubilet

photographer Bates Littlehales and
optical engineer Gomer MacNeil. It
used an 8-inch Plexiglas compass dome
that corrected the magnification of the
water, and held a Nikon F camera
with the newly invented sports finder.
I could use macro lenses and wide
angle lenses, even a fisheye lens. I
could shoot a shark or a shrimp. I
could shoot the sea. Strobes replaced
flash bulbs. It was 1969.

CIRCLE OF BARRACUDA

Off New Ireland in Papua New Guinea, I swam into a school of Pacific barracuda. They circled and surrounded me, reflecting the afternoon light. Caught in the middle of a very extraordinary scene, I instinctively knew that *I* was the picture. I raced back to the dive boat *Telita,* flopped up on deck and begged Captain Dinah Halstead to come with me so that *she* would be the picture.

We swam together into the barracuda school, and as they began to circle us, I dove for the bottom, gritting my teeth and mentally crossing my fingers. At 50 feet, I rolled on my back and looked up. Dinah was in a magical dance. She put out her hand, the barracuda circled once, twice, then they were gone.

It was a moment in the sea that made all the work, all the ancient, giant battles with horrible equipment worthwhile.

Nikon F3 camera in an Aquatica housing, Nikkor 16mm fisheye lens, a Sea & Sea YS strobe, Kodachrome 64 film.

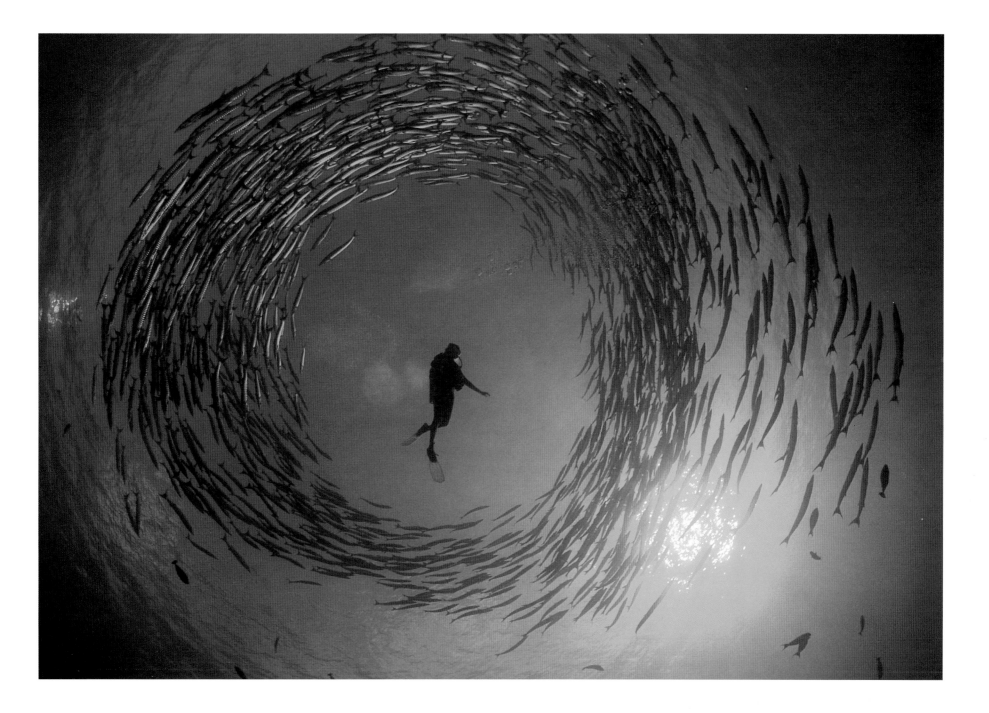

CIRCLE OF BARRACUDA

David Doubilet

Tim Fitzharris
UNITED STATES

● ● ● ● ● ● ● ● ● ● ● ● ● ● ● ● ● ● ●

For me, light is the most important consideration when photographing wildlife, so I restrict my shooting to the hours around sunrise and sunset. Shooting at any other time is a waste of film, as I am not as interested in behavior or species types as I am in textures, colors and patterns. Abstract treatments which convey a mood or feeling, rather than information, often produce a more sustained appeal and allow the viewers to interact with their own thoughts, memories and visual precepts.

What and where I photograph is determined by whatever book project I am working on. I spend about half the year in the field and half the year at home editing photographs and writing.

My favorite subjects are birds, and I prefer to shoot water birds—ducks,

PREENING SPOONBILLS

The last time I was at Ding Darling National Wildlife Refuge in South Florida, it was crowded with photographers, scores of them, many carrying super telephoto lenses which they aimed, often en masse, at the beautiful array of wading birds that congregates in the lagoons and tidal flats during the winter. The scene approached a social exercise as photographers from around the world shot and held conversations at the same time.

As the sound of a dozen shutters rapidly firing announced the take-off of another heron or ibis, I wondered if we were all taking the same photo. Who wins—the guy with the longest lens? Shouldn't wildlife photography be an undertaking of self-expression?

Late in the evening after the sun had set, I started down the trail to one of the refuge's roadside ponds. Other photographers were going the opposite way, returning to their cars. As I reached the pond, a flock of spoonbills glided in, landed silently in the shallow water, and began to clean their feathers before roosting for the night. The dim light required an exposure of 30 seconds, even with the aperture wide open, resulting in blurred heads but sharp legs.

Canon F1 camera, 500mm lens, Kodachrome 64 film.

70

PREENING SPOONBILLS

Tim Fitzharris

grebes, waders, shorebirds—usually from a floating blind away from the nests. This allows me to approach my subjects quite closely without disturbing them. The water produces attractive reflections, and if there is any splashing by the birds, it also leaves a trail of action which the lens records. I usually spend three to four hours at a time in the blind.

I prefer to work in secluded marshes or quiet seashores on private or tribal lands where tourists, sportsmen, and government officials are scarce. But shooting a dragonfly resting on a lily pad, its wariness intact, its beauty unnoticed, rekindles the spiritual essence of nature photography, even if the creature resides in a pond in New York City's Central Park.

I have no comforting illusions that my work can do anything to stop or even slow the rate of environmental decline and loss of wildlife. The only comforting thought is that at some point nature will make things right; she will redress the imbalance.

Meanwhile, I keep photographing and writing about nature and wildlife for no other reason than it is the most peaceful, enjoyable way I know to earn a living.

BIGHORN SHEEP

This photograph was made using a down-sized variation of a technique pioneered by a *Life* magazine photographer who used a helicopter to drive giraffes into a larger, tighter, more photogenic and neurotic herd while on assignment in Africa. My method of controlling the movements of these bighorns involved an assistant on foot who received instructions from me by walkie-talkie.

These rams, excited by the rut, were sparring and running about an open meadow on Mount Rundle in Banff National Park, Alberta. My assistant used the sheep's wariness of her to move them past my camera. I was positioned about 75 to 100 meters away, using a shutter speed of 1/30 second, and panning the tripod-mounted camera along with the herd as it ran about the mountainside.

Canon T90 camera, 500mm lens, Fujichrome 50 film.

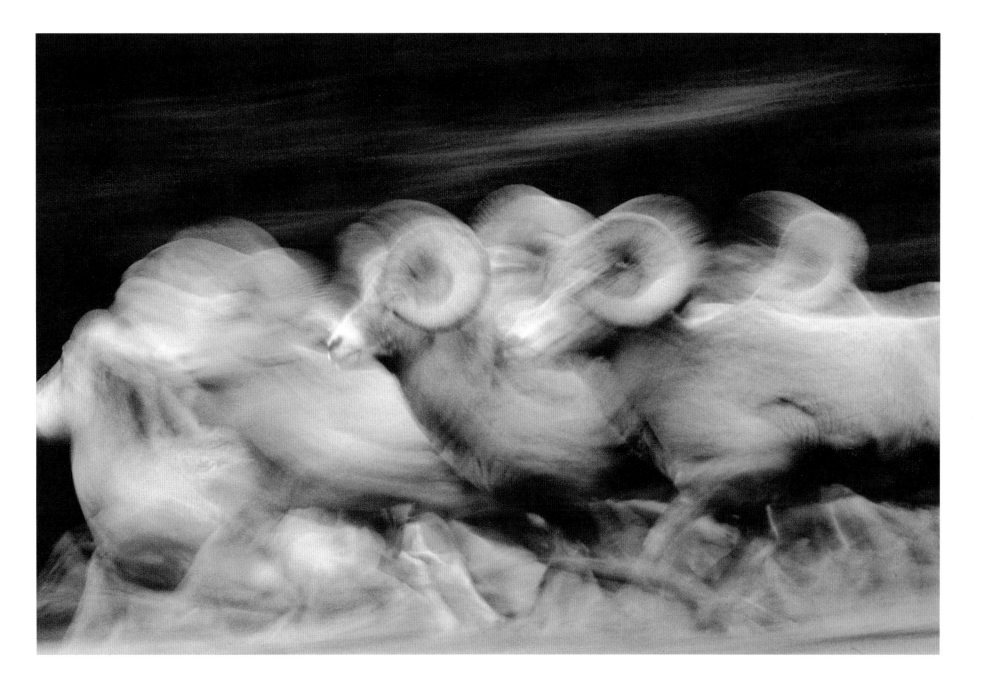

BIGHORN SHEEP

Tim Fitzharris

SERENGETI LIONS AT KILL

When in Africa, I work independently. I hire a native guide who sits in the back or roof hatch of the jeep to spot game. The guide is indispensable in leading me through the maze of bush trails to animal haunts and in getting us back home when shooting is finished.

By doing the driving myself, I can maneuver the vehicle quickly and precisely to where I want it for the best light and camera angle. Using brackets, I can set up a tripod or monopod in the passenger seat of most types of four-wheel-drive vehicles.

Serengeti lions hunt during the night, when available light photographs are not possible. Therefore, the best chance for photography is to set out an hour before sunrise and hope to come upon a kill made late in the night so that the lions are still feeding when the sun rises.

I was led to this scene by a Masai. We arrived when the light was too weak to use an action-stopping shutter speed. Rather than try to time the exposures for when the animals were momentarily stationary, I decided to use exposure times of several seconds which recorded the writhing bodies about the wildebeest carcass as a blurred mix of fur and twitching tails. I photographed from the window of a jeep parked only a few meters from the lions, who were unconcerned by my presence.

Canon T90 camera, 500mm lens, Fujichrome Velvia film.

74

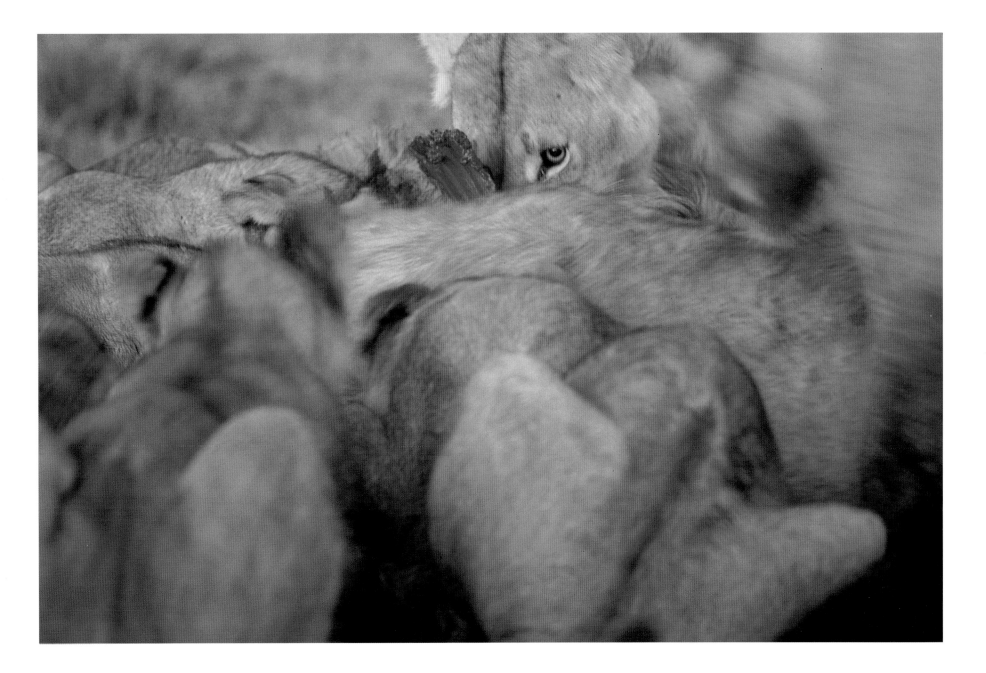

SERENGETI LIONS AT KILL

Tim Fitzharris

Michael &
Patricia Fogden
SCOTLAND

• • • • • • • • • • • • • • • • • •

Our photography is strongly influenced by our background as wildlife researchers. We document animal ecology and behavior—the ways in which animals feed, reproduce, and escape predators, and how they interact with plants to their mutual benefit.

But we are not fanatical about photography—getting or not getting "the picture" too often gets in the way of the enjoyment of a wildlife encounter. We would much rather go for a walk without equipment, and often do. It is something of a joke among our friends, many of whom claim never to have seen us with a camera.

SCINTILLANT HUMMINGBIRD AT FLOWERS OF AN EPIPHYTIC HEATH

In recent years, we have devoted a lot of time to photographs of hummingbirds visiting and pollinating flowers. We have many pictures of brilliant, iridescent hummers at gaudy tropical blossoms, but prefer this one of an immature hummingbird visiting small greenish flowers normally pollinated by insects.

Weighing in at 2.5 grams (less than 1/10 ounce), the scintillant hummingbird is tiny, one of the two or three smallest hummers in the world, and cannot compete with larger species at conventional "hummingbird flowers." It is so small and visits insect flowers so exclusively, that it could easily be called an "honorary insect."

Hummingbirds are one of the few subjects for which we use a lot of flashes. For this picture we used four, three on the hummer and one on the background. The problem with this type of photography is balancing the flashes to get a natural look and a feeling of light and airiness. All too often the backgrounds to hummingbird pictures are black or obviously artificial. A little movement on the wing tips often enhances a picture, too, making it more "alive," less "frozen."

Nikon F4 camera, Micro-Nikkor 200mm lens, Metz 60CT4 flashes, Fujichrome 50 film.

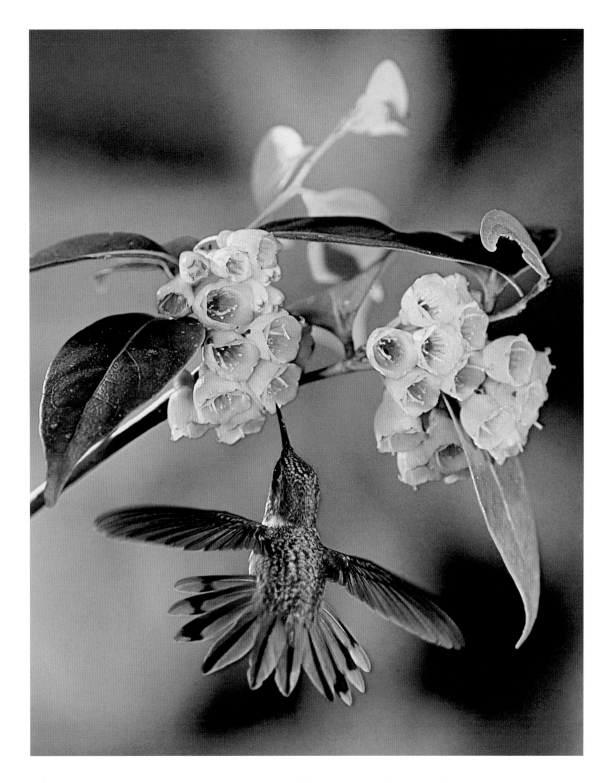

SCINTILLANT HUMMINGBIRD AT FLOWERS OF AN EPIPHYTIC HEATH

Michael and Patricia Fogden

We have spent much of the past 16 years working in the rainforest in Costa Rica and the Amazon basin. The rainforest may have the richest assemblage of animals on earth, but the interesting ones can be difficult to find. The light, or lack of it, is even more of a problem. Beautiful early morning and late evening light doesn't reach the forest interior and there are no sunsets. However, some often mentioned problems are grossly exaggerated. We have had no problems with biting insects, disease, and high humidity in the tropics than in many temperate areas.

SUNBITTERN DISPLAYING ON ITS NEST

The sunbittern is one of our favorite birds. In 1985, we spent six weeks at a sunbittern's nest in a remote part of Costa Rica. The nest was the first to be studied and photographed in the wild and, in a brief return to our research roots, our observations were published in a scientific journal.

Both male and female sunbitterns have exquisitely colored wings bearing a sunburst pattern of chestnut and gold. Fully displayed, the wings resemble two enormous staring eyes that are flashed as a threat display at predators and photographers. The threat display was the picture we coveted.

Both parents were very shy at first, slipping away as we approached our blind (which was perched on top of a small wooden tower erected on a rock in the river). But by the eighth day of incubation, one bird stayed on the nest and displayed.

The nest was built on a branch growing from a cliff above a rushing torrent. Moss, ferns, orchids and bromeliads grew in profusion on every rock and branch. It was a verdant but gloomy site, made even gloomier by an almost perpetual overcast. Flash would have detracted from the subtle beauty of the setting, but there was usually too little light for a successful ambient-light exposure, even with fast film. We knew that our only hope for adequate light was a period of 30 minutes or so in mid-morning when the sun sometimes shone on the white foaming rapids below the nest, bouncing fill light onto the bird above.

We didn't know it at the time, but there were to be only two days when the sunbitterns would display for us (they totally ignored us thereafter). And we needed sun within the 30-minute time frame on one of those two days. We were lucky. We got our picture on the first day and it poured on the second.

Nikon F3 camera, Nikkor 400mm lens, Fujichrome 400 film.

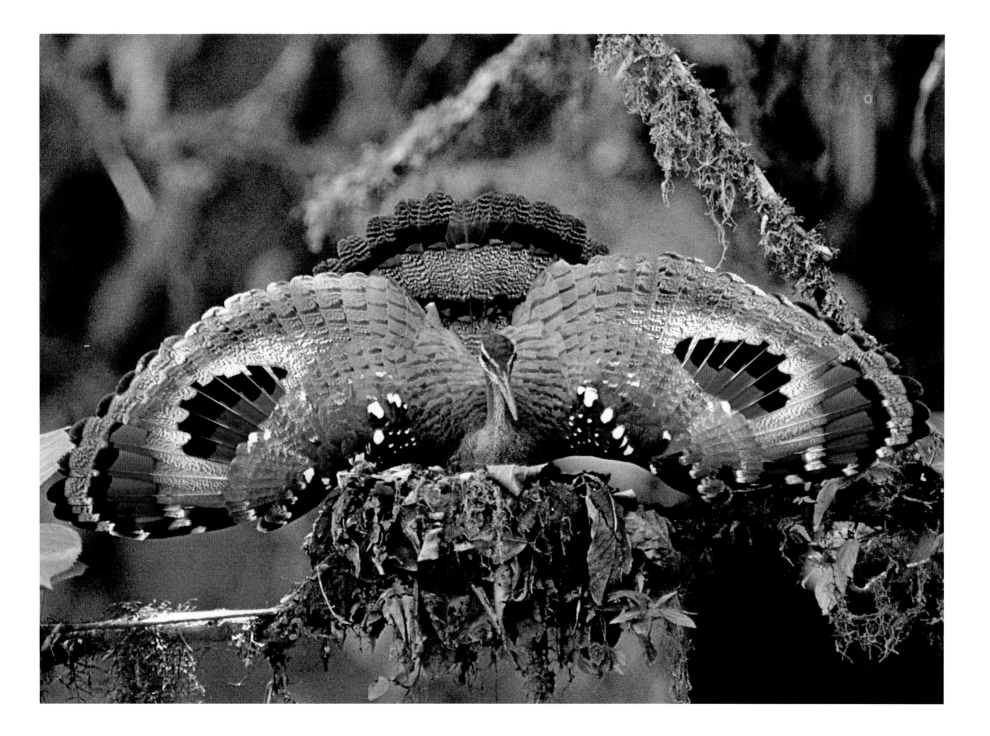

SUNBITTERN DISPLAYING ON ITS NEST

Michael and Patricia Fogden

PERINGUEY'S ADDER ON NAMIB DESERT DUNES

Recently we have been visiting Africa's Namib Desert for a month or two each year. Peringuey's adders are common on the desert dunes of Namibia, though difficult to find. They spend most of their time buried, with only their eyes visible, and when they do move, their characteristic "sidewinder" tracks are quickly covered by blowing sand. To find this one, we had to wait for a calm morning and follow its tracks for half a mile. We returned in the evening, when the low sun was casting long shadows, and photographed the adder as it made its escape, sidewinding up a dune.

For the desired effect, we needed a wide angle lens about two feet from the snake, which was moving rapidly and more skillfully up the dune than we. Holding focus, composition and a level horizon, while struggling up the dune, bent double, was a little tricky. Peringuey's adders are not dangerously venomous but they are irascible little snakes, and this one struck repeatedly at the camera (or the hands holding it). From a distance of only 18 inches, even a small angry snake keeps you quite alert.

Nikon F4 camera, Nikkor 35mm lens, Fujichrome 100 film.

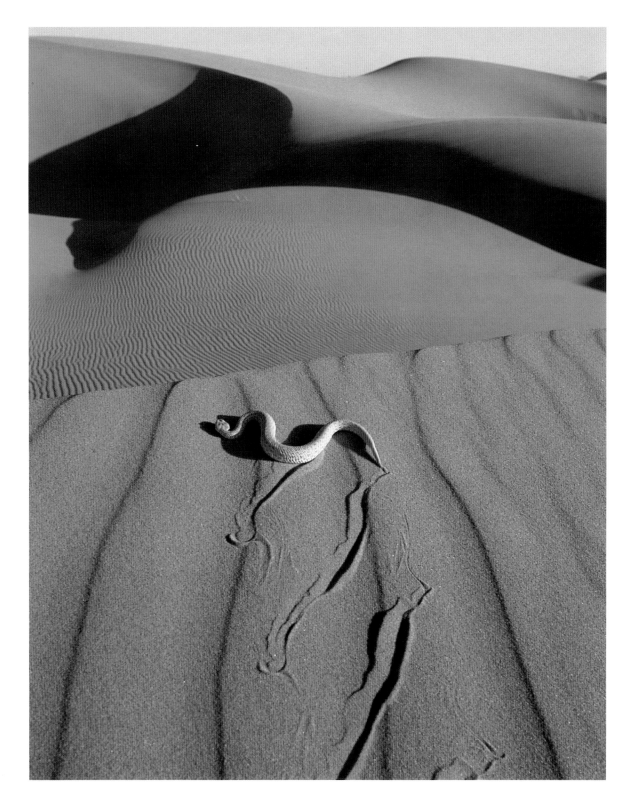

PERINGUEY'S ADDER ON NAMIB DESERT DUNES

Michael and Patricia Fogden

Howard Hall
UNITED STATES

• • • • • • • • • • • • • • • • •

I've always been a diver, and paid for my college education by teaching diving. After graduating, I decided that a career in underwater photography was the best way to combine my knowledge of marine life and my diving skills. Still, it took many years before I could earn a full-time living from underwater photography.

Today my career has turned primarily toward the production of films about marine life. Television film budgets provide the expensive charter fees for working in isolated locations for the many months required to capture

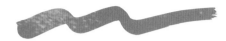

MANTA RIDE

I had been filming schools of hammerhead sharks at 130 feet near the Marisula Seamount in the Sea of Cortez. Stan Waterman and Peter Benchley were with me when, our bottom time gone and air supplies low, we ascended to the summit of the undersea mountain. What we saw when we reached the summit took our breaths away. My wife, Michele, was flying over the seamount, perched on the back of a 20-foot-wide manta ray, frantically trying to remove a tangle of fishing net that was wrapped around the animal's head. As we watched, the manta and Michele slowly flew away into the deep water behind the seamount. None of us had ever seen anything so beautiful before. I wasn't sure I would ever see Michele again.

With help, Michele eventually succeeded in removing the net from the manta. For the next ten days, the giant manta followed us around, hanging below us as we decompressed or hovering above us as we worked on the bottom. It constantly encouraged our contact.

It seemed an anthropomorphic cliché—Androcles and the Lion. But we soon discovered that other rays in the area reacted similarly to our touch. If we were allowed to approach close enough to touch a manta, it would often stop and encourage further contact. Many times, a ray would follow divers back to the boat after contact was broken. I once watched a manta wrap its wings entirely around Bob Cranston as he scratched a particularly sensitive spot on the ray's stomach.

Ironically, I might not take this photograph today given the opportunity. Things have changed since I captured this image in 1981. Mantas were common in the Sea of Cortez then. A few years later, they were gone. Many divers felt the practice of manta riding (which became popular soon after this photograph was published) drove the mantas away from the Marisula Seamount. In the wake of vanishing marine life everywhere, the sport diving industry began to frown on riding manta rays. This new, more gentle ethic is one I enthusiastically support, though with a trace of sadness.

Yet, the truth is that divers didn't frighten the mantas away from the Marisula Seamount. In the few years that followed 1981, commercial fishing nets decimated the mantas that once soared all through the Sea of Cortez.

Nikonos III camera, 15mm lens, Subsea Mark 150 strobe, Kodachrome 64 film.

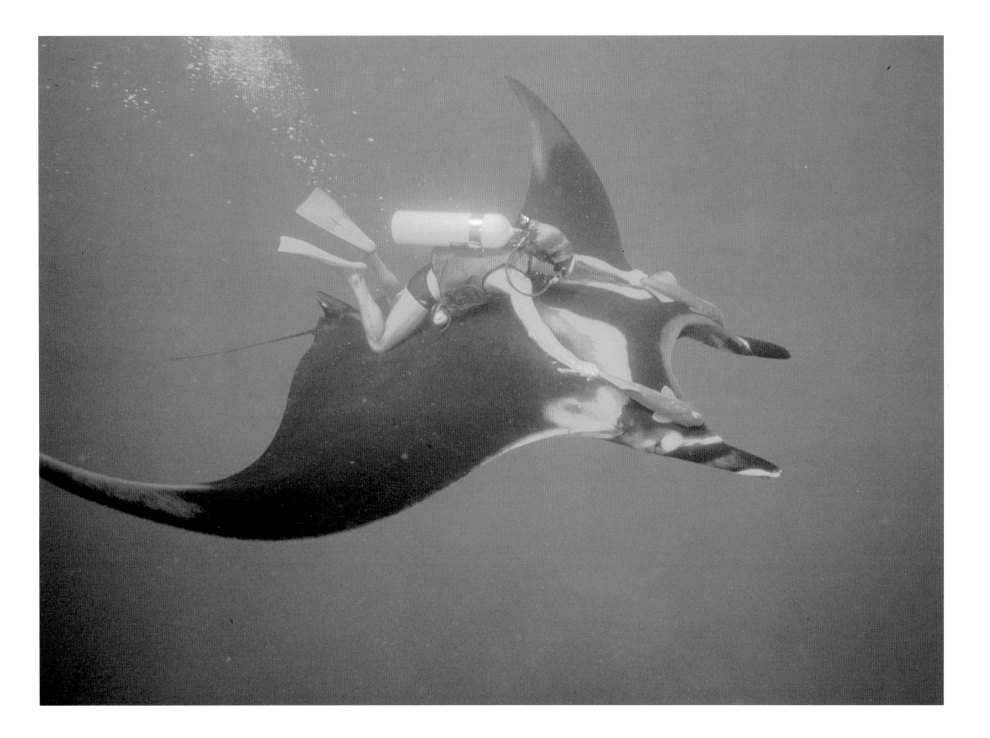

MANTA RIDE

Howard Hall

animal behavior stories on film. And though I now spend most dives working with a bulky movie camera system, my still camera is never far from reach.

BASKING SHARK

No one knows where the basking sharks come from when they suddenly appear in the waters off Santa Barbara, California. Some believe the 25-foot sharks actually hibernate on the ocean floor, partially buried in mud, as they wait for the spring plankton bloom. More likely, they may simply spend most of the year feeding on unknown resources in the unreachable depths. But when the plankton blooms in spring, it somehow beckons basking sharks to the surface.

In the channel between the city of Santa Barbara and Anacapa Island, I watched groups of a dozen or more basking sharks slowly gliding through the murky water with mouths agape as they strained thousands of gallons of water for tiny prey.

I wanted a photograph looking directly into that huge open maw. But as they approached within shooting distance, and the sharks became aware of me, they always closed their mouths.

After a few days of experimentation, I figured out how to work it. As the sharks approached, I would free dive 20 feet or so below the school. As the first shark passed, I would ascend right beneath its belly. Concealed by the shadow of the first shark in the school, the others didn't see me until I emerged from under the first shark's tail, only a few feet from their open mouths. One time, my movie camera actually went inside a shark's mouth before it was aware of me. I pulled the camera out just before the huge orifice closed.

Nikonos III camera, 15mm lens, Ikelite Mark 150 strobe, Kodachrome 64 film.

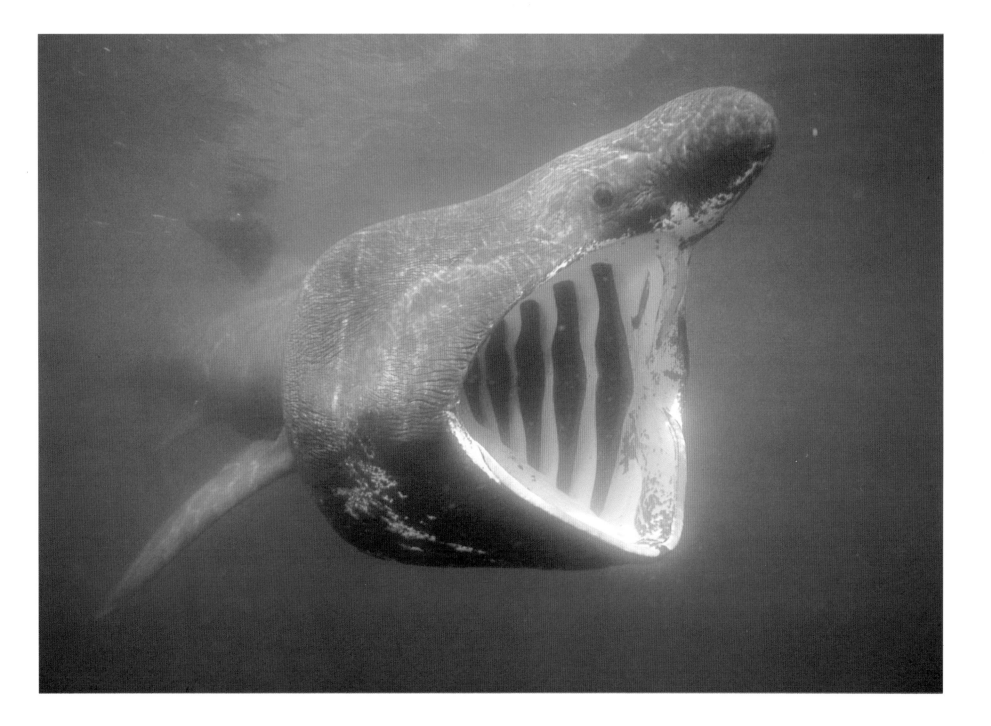

BASKING SHARK

Howard Hall

GRAY WHALE IN THE KELP

In 1976, I found this 30-foot-long yearling gray whale swimming through a kelp bed near San Diego, California. It seemed to enjoy gathering up large quantities of kelp fronds in its mouth and chewing on them.

I decided to photograph the whale from above water. I put on fins and wet suit, slipped into the water, and for the next two hours followed the whale as it moved through the kelp, chomping on fronds. It was exhausting. Even though the whale was swimming slowly, it was still moving as fast as I could swim through the heavy kelp. It took every ounce of strength I had to swim into position for a shot as the whale swam by. I would have only a moment to take a single photograph. Then I would have to swim to a new position for another shot, all the while holding the camera high over my head in an effort to keep water drops off the lens. By the end of the day, I had shot the entire roll of film, but I was completely exhausted.

When I got the slides back from the processor, I was horrified. The results were pathetic. Almost all of the photographs were out of focus either due to camera movement or just bad focus settings. Those that were sharp suffered either from terrible composition or water drops that had splashed on the lens despite my best efforts. I threw every slide away without second glance, until there was only one left in the box. This one.

Nikonos II camera, 35mm lens, Ektachrome 64 film.

GRAY WHALE IN THE KELP

Howard Hall

Mitsuaki Iwago
JAPAN

• • • • • • • • • • • • • • • • • •

When I am in front of wild animals,
I forget to think Most of my good
photographs were taken while I was
ecstatic at losing myself in that
particular magnificent moment of life.

What is most enchanting about nature
photography is its unpredictability. It
is fascinating to take pictures of
animals when you just don't know
what they are going to do next.
Something far beyond your
imagination could happen right in
front of your eyes, and you click the
camera to capture that moment.

I have been a nature photographer for
24 years, but I still have failures from
time to time. I wish I could say that

CHEETAH IN THE SERENGETI

I photographed this female cheetah in the Serengeti National Park of Tanzania, East Africa. Normally, a cheetah is a very shy animal, the degree of shyness depending on the individual. But I was lucky in that I was able to observe her and the growth of her four kittens for about a year.

I began by photographing a few cheetahs in the Serengeti Plain for the purpose of scouting out one particular cheetah that would be unconcerned about my vehicle and would exhibit natural behavior. After a while, I concentrated on this female cheetah, because she gradually became accustomed to me and my vehicle. By watching her, I also started to learn the kinds of places cheetahs like in the Serengeti Plain, and the relationship between seasons and the herbivorous animals on which they prey. I realized that they seem to prefer a horizontal field as grand as the Serengeti Plain.

This image of the mother cheetah, with her back coming in and out of withered grass in the dry season, and stealthily approaching a Thompson's gazelle, was extremely beautiful. The moment of the catch, of course, was quite moving, too. I will never forget the wind blowing in the Serengeti Plain and the grass swelling like waves in an ocean.

Leica R3 camera, Telyt 400mm lens, Kodachrome 64 film.

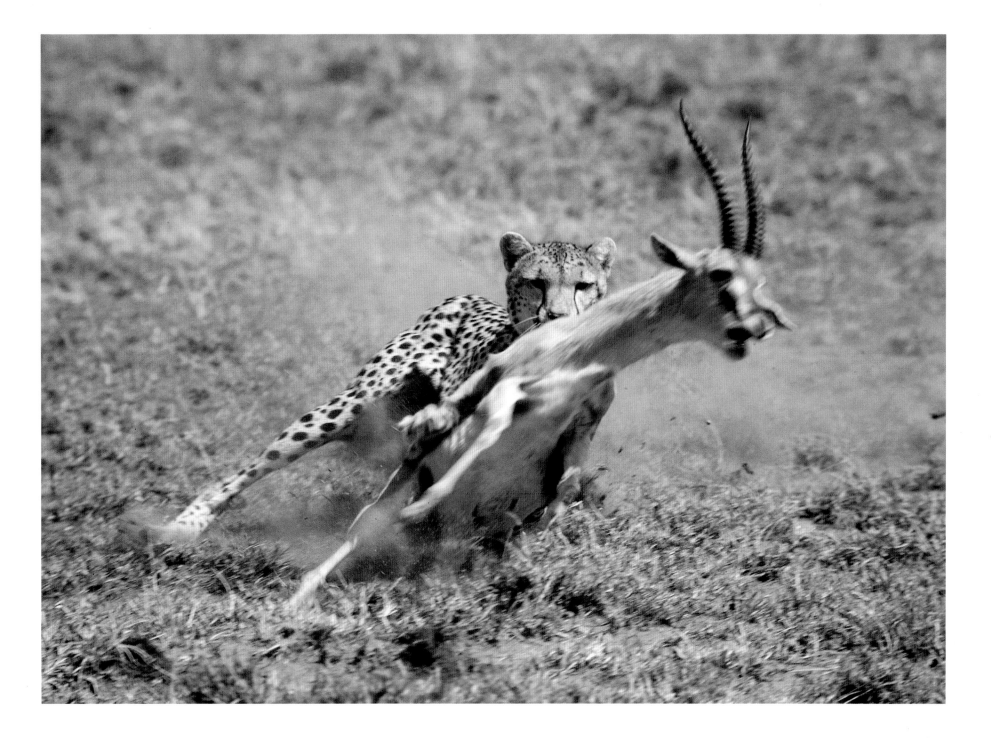

CHEETAH IN THE SERENGETI

Mitsuaki Iwago

*I'll never make the same mistakes
again, but I probably will. I just
want to keep trying.*

*My knowledge and my experiences as a
human give me no advantage in
taking pictures of wild animals. In
fact, they can be a detriment. For
example, when we see monkeys, we are
often tempted to wonder what the
monkeys are doing. Then we tend to
think anthropomorphically, and try to
find the answers in comparison to our
own human activities. But monkeys
are monkeys. Their behavior cannot
be understood using the same measures
as ours.*

*However, if I ever see monkeys
throwing snowballs at each other with
laughter, or a grinning monkey hitting
his fellow with a twig in his hand, I
would love to take pictures of them!*

HUMPBACK WHALE

I photographed this humpback whale in Alaska's Frederick Sound, but I had started, early in the year, photographing humpback whales off the island of Maui in Hawaii. Humpback whales come to the clear blue sea of Hawaii during winter. They choose those warm and safe waters to give birth to their calves and to raise them there. I was affected from the bottom of my heart by my encounter with humpback whales in the sea. Perhaps the unique underwater surroundings made me feel that way.

Humpback whales eat almost nothing in the sea around Hawaii, because there are few living things for them to eat in such transparent water. After not eating for nearly a half year, they again move north toward the sea of Alaska, where food is abundant.

I also dove with them there, in the ocean off Alaska. The water there is different from the water of Hawaii, and the color is green, not blue. That indicates that the sea is rich in life, and the whales eat excitedly. As they start feeding, sardines and herrings jump in and out of pools made inside their jaws. It shows how huge the whales are. You can also imagine the grandness of the sea where they live.

Leica R5 camera, Apo Telyt 180mm lens, Kodachrome 64 film.

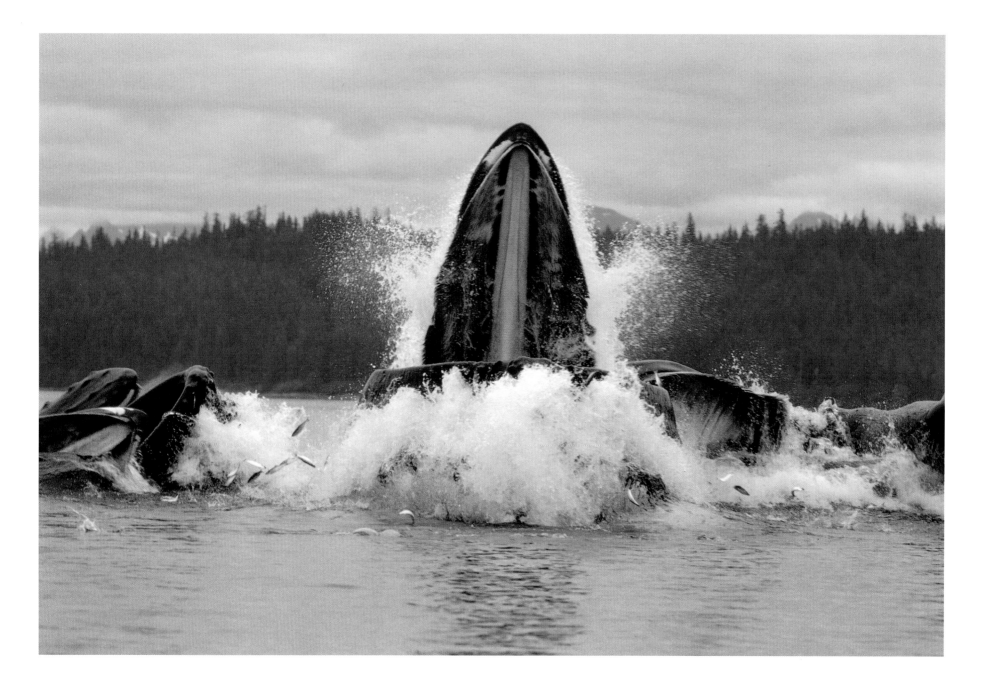

HUMPBACK WHALE

Mitsuaki Iwago

Nile Crocodile and Gnu (Wildebeest)

A Nile crocodile preys on a gnu in merely a moment. I spent two months in the western region of Tanzania's Serengeti National Park to photograph that very moment, which was less than a second. To wait is natural for me, just as it is for Nile crocodiles, who must wait for a half year for the gnus to return.

Watching this drama in Serengeti National Park, I saw the rhythm of nature repeated over and over again.

Leica R7 camera, Apo Telyt 250mm lens, Kodachrome 64 film.

92

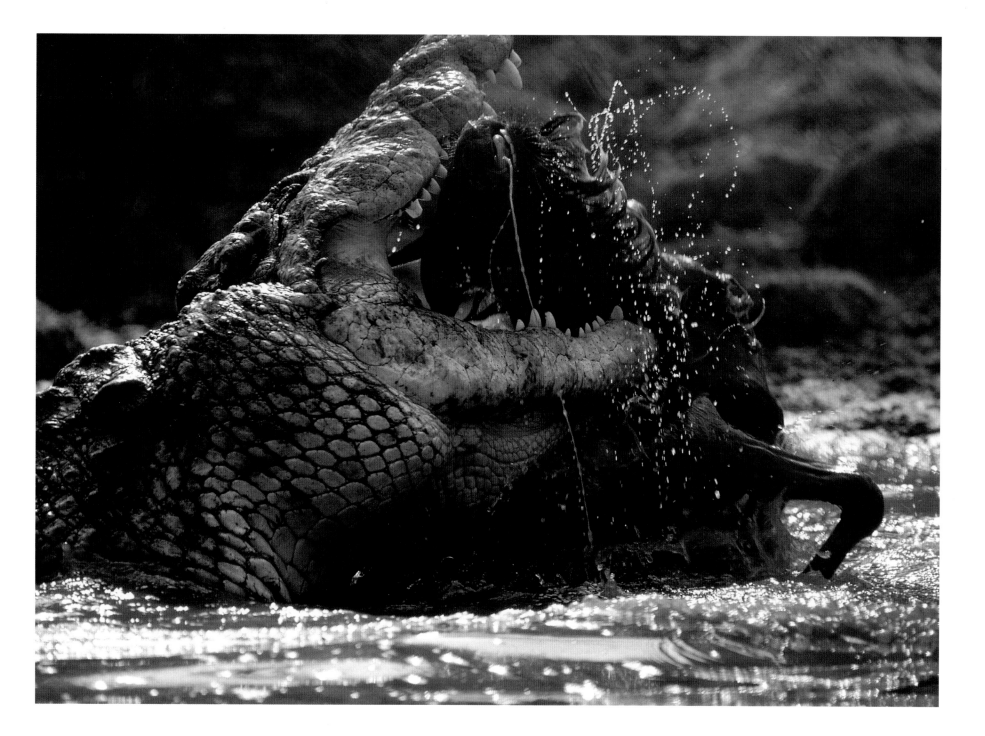

NILE CROCODILE AND GNU (WILDEBEEST)

Mitsuaki Iwago

Stephen J. Krasemann
UNITED STATES

• • • • • • • • • • • • • • • • • • •

Moments. That's what wildlife photography is all about. Moments that often happen but once. When all the conditions are right... when you have the right lens on your camera, when the subject will stay close while you compose the photograph, and when you're able to focus and expose the right amount of light onto the film.

I try either to combine all the elements I can see into a photograph— background, colors, composition, and subjects—to create the most complex picture I can, or I try to reduce the picture to its simplest form—one subject, no confusing background, and plain composition.

MALE CARDINALS

This picture of the cardinals happened because I spend so many hours outdoors, although the time spent outdoors was combined with another element that often occurs to produce wonderful photographs: luck.

It just so happened that two bright red males (female cardinals are a duller reddish brown-gray) landed within the borders of my photograph at the same moment. Though it was luck, I love the added element of color.

Nikon F4S Camera; 200-400mm Nikkor lens; Fujichrome Velvia film.

94

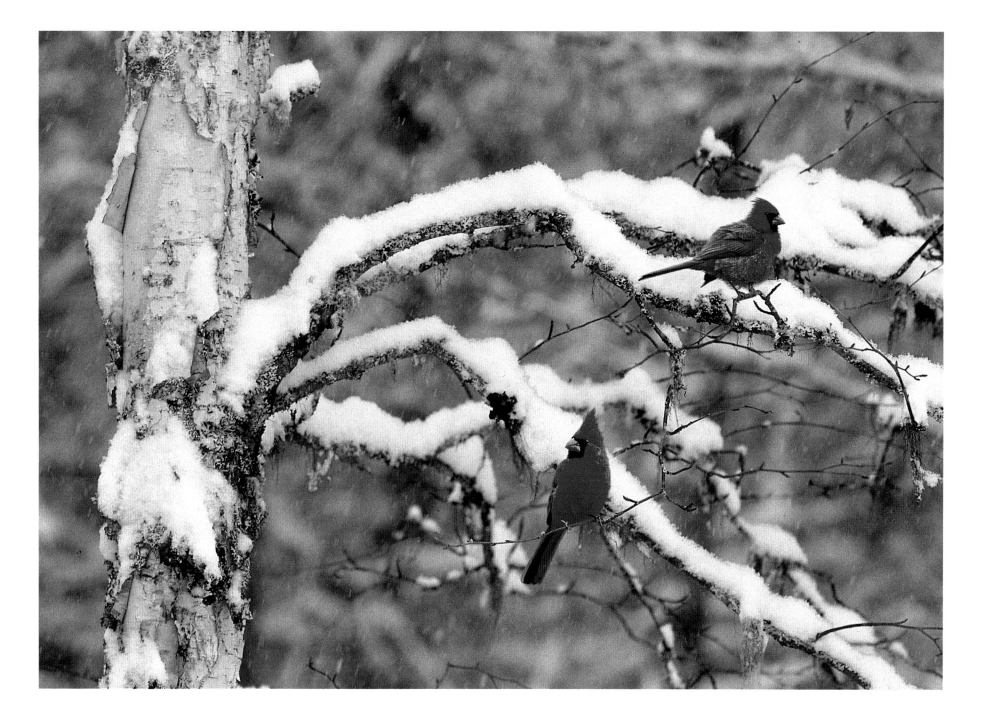

MALE CARDINALS

Stephen J. Krasemann

With today's cameras and lenses, it is relatively easy to take a good, often excellent, sometimes great photograph. Although I believe what separates the top professionals is their ability to take myriad good and excellent photographs, and more than the average great photographs.

Wildlife photographers spend a lot of time in the field preparing to take pictures. We scout locations, approach many animals that either run or fly away out of camera range, and often we sit for long hours in photographic blinds waiting, waiting, waiting. I can't count the times people have told me, "You must have a lot of patience."

Twenty years ago, when I began trying to become a professional wildlife photographer, I didn't have any clue what it took to make a living in this business. And it was partly this ignorance that allowed me to succeed, because if I had known how long it would have taken before I could piece together enough photo sales, month after month, year after year, coupled with the numerous photographic rejections in the early years, I doubt I would have pursued this profession.

Other aspiring professionals ask me for my advice. It goes something like this: If you have to question whether you should become a professional wildlife

DOE WITH TWO FAWNS

I had been working on the book *Way of the Whitetail* off and on at a number of locations for almost three years, and was looking for more deer pictures on the Apostle Islands during this particular summer.

I spotted these fawns in the grass and had photographed them before they laid down. After they laid down, I wondered if I should stay there and wait until they got up, when all of a sudden the doe came out of the woods and saw me. I backed off a little bit farther, hoping that those were her fawns and that she would go to them.

Sure enough, after a brief period of time she did approach the fawns, checking, by scent, to make sure that they were her fawns. That's what's happening in this picture: they're almost touching noses to be certain that they are indeed each other's relatives.

Nikon F4S camera, 200-400mm lens with 1.4 tele-extender; Kodachrome 200 film.

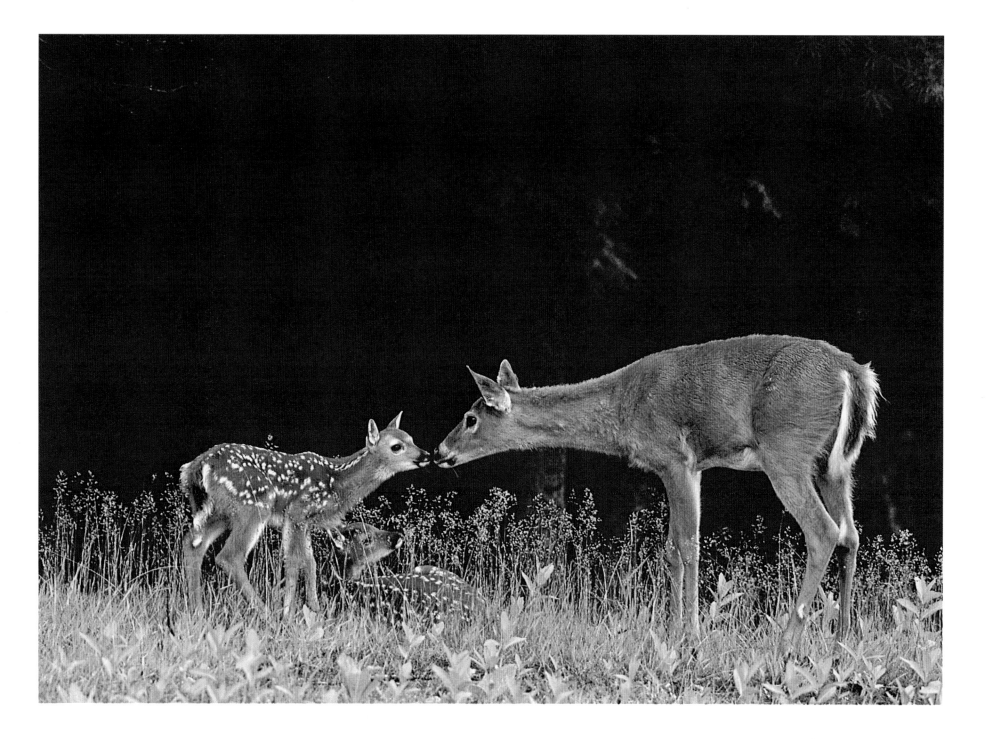

DOE WITH TWO FAWNS

Stephen J. Krasemann

photographer, you don't have the fortitude to make it through all the spirit-deflating setbacks of the early years.

However, as Ranger Rick's *executive editor Bob Dunne told me at the beginning of my career, "If you have the persistence and take a wide variety of pictures, you'll be able to make a living photographing wildlife."*

MOUNTAIN LION

This photograph was done during the two years I worked photographing mountain lions for *Geo* magazine. We had used a variety of techniques to photograph them, everything from trying to lure them to roadkills that I had fitted with remote control cameras to tracking them with hounds on leashes.

This particular day was very hot—in the upper 90s—on the Mexican border, probably on the Mexican side in the state of Sonora. We had trailed this mother and her two yearling cubs until we got to this arroyo canyon. It was all in the shade, and that's where the cats had headed, across the hot desert sun, into the coolness of the canyon.

We walked into the canyon to see if we could find the cats, and we did. They were on the opposite side of the canyon, and very reluctant to go back out into the desert heat. They had found themselves a nice little rock outcropping that had a little eroded cave in it, and they just rested there for a long time. We were at least 75 feet from them, on the same level as the cats, but across a dip in the canyon, so they felt safe.

It was cool there and we weren't bothering them, and over a period of time they started relaxing. In this picture, they are starting to take a nap. Cats are like that. When they're not being harassed and nothing's right in their face, they can relax pretty well.

Nikon FE camera, 400mm Nikkor lens, Kodachrome 64 film.

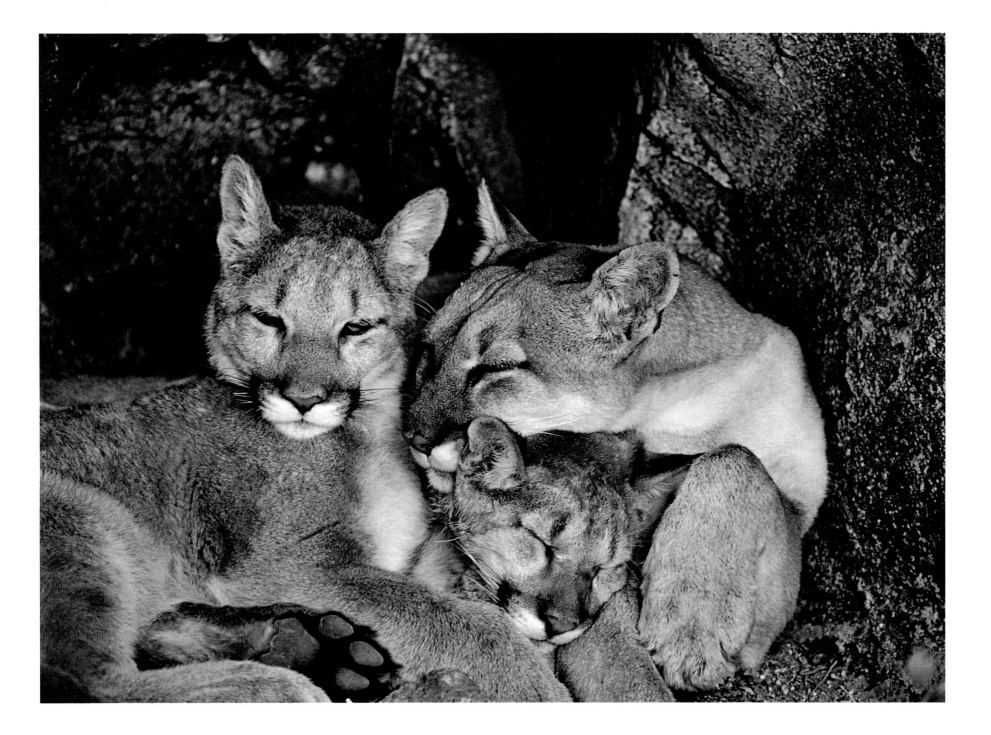

MOUNTAIN LION

Stephen J. Krasemann

Frans Lanting
UNITED STATES

· · · · · · · · · · · · · · · · · ·

A Kwakiutl elder once led me to a
secluded cave on a small island off the
west coast of Canada where he told me
this story. Once upon a time, all
creatures on the face of the earth
were one. Even though they looked
different on the outside, they all
spoke the same language. From
time to time, they would come
together at this cave to celebrate
their unity. When they arrived at
the entrance, they all took off their
skins. Raven shed his feathers, Bear
left his fur, and Salmon her scales.
Inside the cave, they danced. Then
one day, a human sneaked up to the
cave and surprised the animals in the
act of dancing. Embarrassed by

WANDERING ALBATROSS

My fascination with albatrosses goes back to the time in my boyhood when I saw a picture of two men holding one up by the spread tips of its improbably long wings. Ever since, I've been hooked on these magnificent seabirds and I have returned time and again to opportunities to translate that interest into photographs that express the awe and affinity I feel for them. During a circumnavigation by sailboat of remote South Georgia Island on assignment for *National Geographic*, I lived with a small colony of wandering albatrosses, camping next to their nest site. Since the birds have almost no natural enemies and they rarely ever come into contact with human beings, they had little fear of me. That enabled me to compose an image that is at once intimate and open. With my knowledge of albatross behavior, I could anticipate the moment when a male, out to impress a female, opened his glorious 12-foot wings.

Nikon FE2 camera, 18mm lens, Fujichrome 100 film.

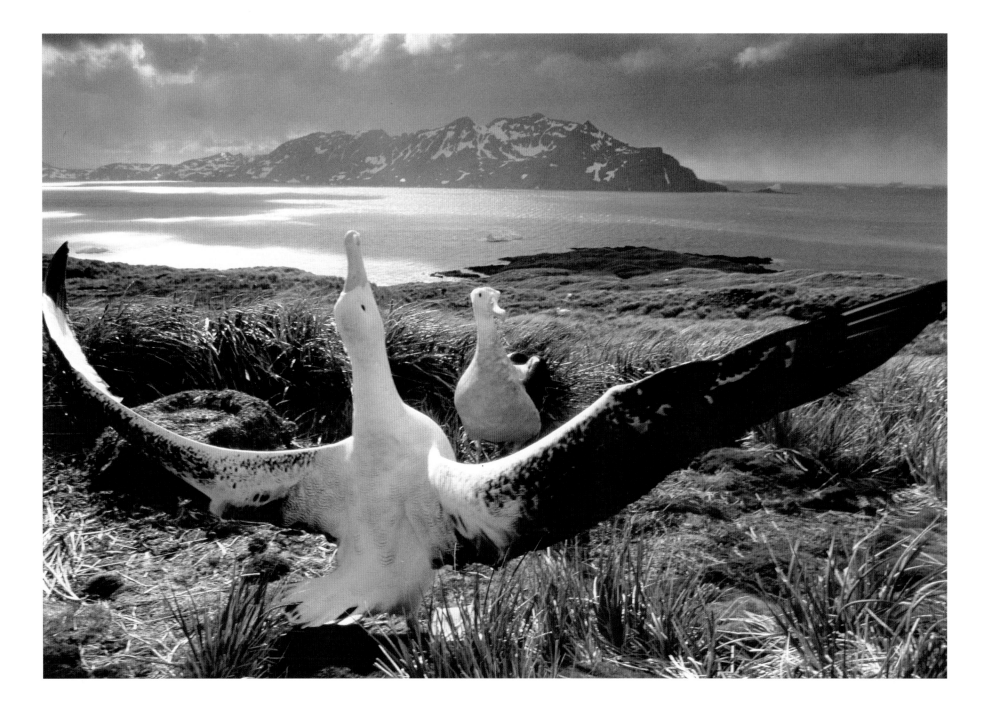

WANDERING ALBATROSS

Frans Lanting

their nakedness they fled, and that was the last time they revealed themselves this way.

The mythical understanding that underneath their separate identities all animals are one has been a guiding principle in my photographic work for many years. What my eyes seek is not just the beauty traditionally revered by nature photographers. The perfection I strive for in my photographic compositions is a means to show the strength and dignity of life in nature. When I raise my camera to other creatures, I aim to get past feathers, fur and scales. I like to get under the skin. It doesn't matter whether I am focusing on a three-ton elephant or a tiny tree frog, I have to get up close and face them, eye-to-eye.

Sometimes it is easy to see the connections between humans and the rest of creation this way. The bonds are clear in the case of the bonobo, the great ape who is most like ourselves. Other times it is harder; a cold-blooded marine iguana does not reveal much of its inner life. I have to take more time and reach back into the recesses of my mind to conjure a sense of its world.

We now know that we share as much as 98 percent of our genes with our closest cousins in the animal kingdom.

AFRICAN DAWN

During my year-long photographic coverage of wildlife in the Okavango Delta of Botswana, I developed a number of concepts to help structure my perspective on this most remarkable water wilderness in the midst of the Kalahari Desert. One theme was the African night, which to me seemed a photographic frontier. Another theme was the last of the oversized animals we call megafauna, especially elephants. I covered details of their natural history and became intrigued by the symbolism of their forms, but ultimately I was most inspired by the sculptural qualities of these great beasts. I found a water hole where I spent much of my time, becoming a fixed point in the landscape, and instead of trying to anticipate where animals might be, I waited by the water hole and allowed them to move in around me. In this image I was able to combine both themes. Scores of doves visit the water hole at dawn. By selectively illuminating one dove, and reducing the elephants in the background to elementary shapes, I was able to suggest the elephants' primeval presence and the bright moment of the day's return.

Nikon FE2 camera, 24mm lens, Kodachrome 64 film.

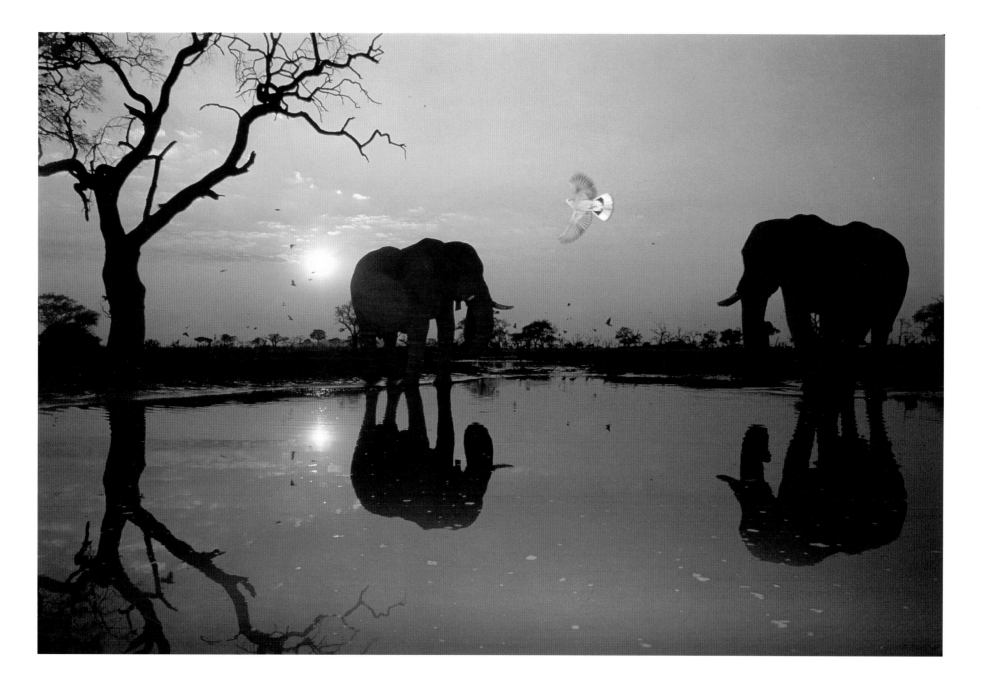

AFRICAN DAWN

Frans Lanting

What I try to do as a photographer is to use that small difference in our genetic makeup which has given us the ability to imagine, and look back at all that we have in common with other animals. And sometimes, it is still possible to see them dance.

SNOW GEESE

For thousands of years, California's Klamath Basin has been a funnel along the Pacific Flyway through which millions of waterfowl pass on their annual migratory journeys between the Far North and wintering grounds in temperate climates. When I first visited there shortly after my arrival in California from Europe in 1978, I was overwhelmed. To me, the annual torrent of birds descending on the marshes represented the vitality and natural abundance that makes the natural history of North America at its best so different from that of Europe.

During two winter seasons of field work, I grappled with the question of how to make photographic sense of this avian extravaganza. Inspired by the work of Ernst Haas in his classic book *The Creation*, I began to experiment with impressionistic images of snow geese in fight. Through trial and error I determined the best shutter speeds and vantage points for a variety of flight patterns, arriving eventually at images which blurred most of the details, making it difficult to focus on any one individual, but holding true to the sensory overload I felt facing this blizzard of birds.

Nikon FE camera, 300mm lens, Kodachrome 64 film.

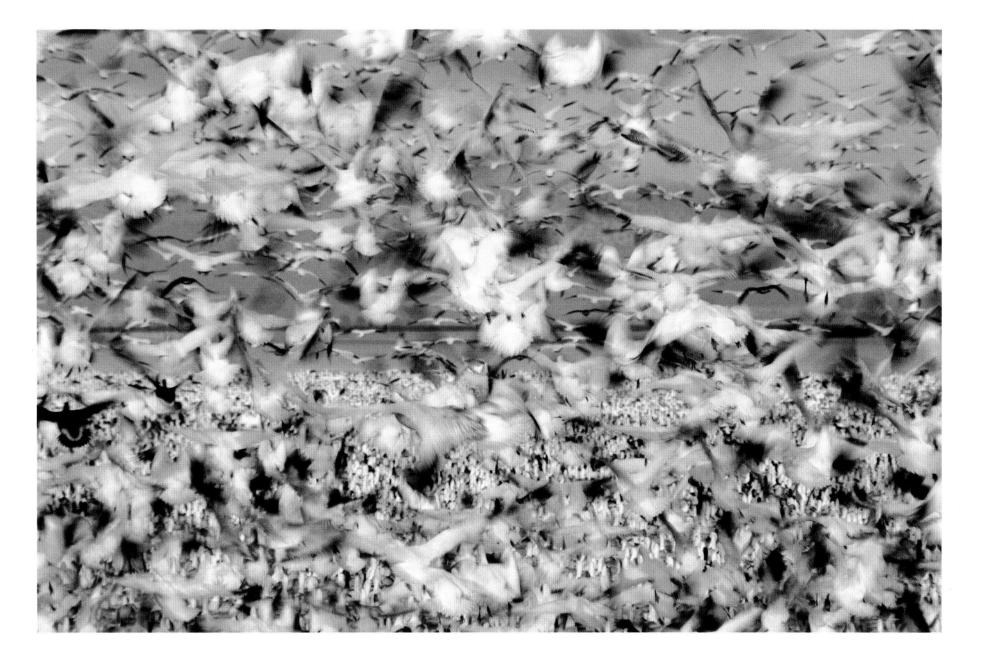

SNOW GEESE

Frans Lanting

Mark W. Moffett
UNITED STATES

. .

From my desk calendar, a tiger peers at me behind leaf sprays. I flip through the months. A whale fin splashes; a butterfly sips nectar; moonlit elephants bathe and trumpet. Each situation has been the subject of countless photographs. Still, these particular images are unbeatable as artistic statements, technically and aesthetically up-to-date.

In the case of magazine articles, however, I believe most images should dig deeper into new photographic territory. I look at nature photographers as natural historians with film, journalists transcending color and design to document the drama of a species' existence.

MOUSE EATING ACORN

Portraits contribute a scene-setting look at an animal, or familiarize us with the appearance of unusual species. An article can then proceed with more complicated action.

My portrait of a browsing mouse comprised part of a larger article in *National Geographic* on acorns. Mice turn out to be heroes of the story, since only acorns buried by mice, squirrels, or similar vertebrates, and subsequently forgotten, have any chance of germination. Otherwise, all the acorns are hollowed out by such insects as acorn moths and acorn weevils, which were the article's main focus. These species bore through the acorn shell and move in.

The plant (oak) side of the acorn story also fascinates me, but plants, being relatively passive, rarely sell as magazine stories without a strong animal component. Choice of topic is crucial even in animal stories. Some species—among them calendar favorites—lead basically tedious lives. Good for them, but not necessarily for wildlife photojournalists, who, if they choose such a subject, will have to struggle all the more to photograph rare or unforgettable moments.

I couldn't cover the mouse's full story in my acorn article, and so it represents one of many unexplored options for "backyard" photographers.

Canon AE-1 camera, 100mm macro lens, Kodachrome 64 film.

106

MOUSE EATING ACORN

Mark W. Moffett

An article's interconnected images tell a story; each one, like a well wrought paragraph, instructs and enthralls. As in ordinary journalism, the goal is to record not simply everyday routine and environment, but decisive moments—actions or events that may occur once in a subject's lifetime, such as a marriage or bereavement might for a human.

For any publication, then, I look at the proportions of three overlapping types of images. For this book, I've selected one photograph of each kind: decisive moments (typically dramatic action); landscapes; and portraits. In the portrait category, I include rudimentary or commonplace behavior images such as a bird brooding her young, snakes threatening the camera, a leopard in a blurry dash. While satisfying when executed well, I think portraits weaken a story when they are too numerous, because they draw little from life's most poignant dynamics. Also, a story feels incomplete if a sweep of the subject's environment—a landscape—isn't introduced.

Usually an article with few dramatic action pictures also suffers, no matter how elegant the presentation or sumptuous the plumage. If the topic were human affairs, viewers might conclude that the photographer had weak emotional and intellectual

TREE-CLIMBING RESEARCHER

Landscapes tend to be statements of ecology: in stories on animals, they place the subject in its habitat, often a vista. Alternatively, the landscape itself may be the subject: this story in *National Geographic* concerned an ecosystem or a place rather than a species. Such stories are hard to do well, particularly in the case of this rainforest canopy effort.

The usual photographer's cop-out: pick the most crowd-pleasing subjects present when the light's good. I try instead to reveal how a community is put together, emphasizing the actions of resident species with key ecological roles (so-called "keystone species"), plus any other unique aspects of that environment. This Costa Rican landscape, for example, portrays the dangers of trees on extreme slopes. Because the trees tilt to reach light, they often topple, setting off landslides (as has occurred in the background). Scientist Pierre Berner—here measuring tree growth—is truly in a precarious position.

Canon T-90 camera, 100-300mm zoom lens, Fujichrome 100 film.

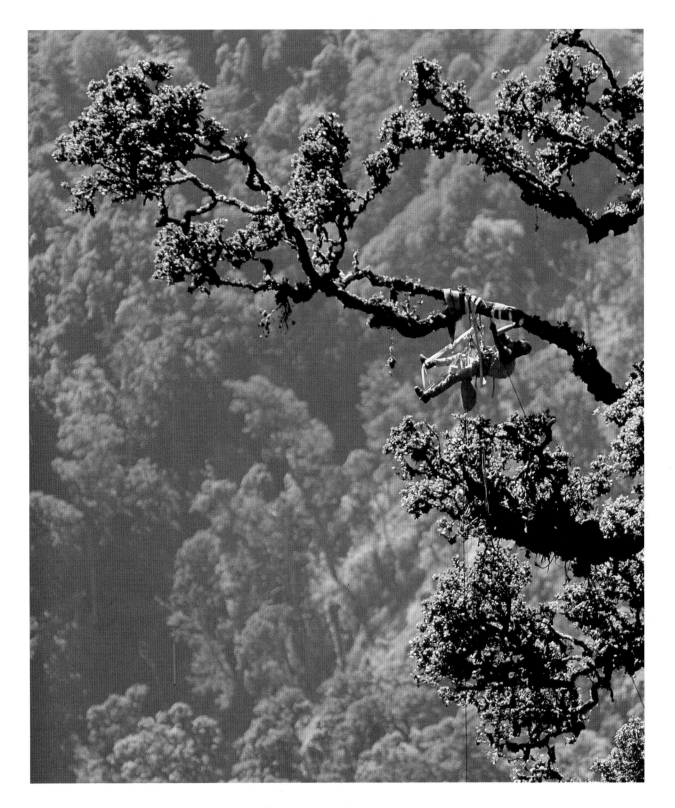

TREE-CLIMBING RESEARCHER

Mark W. Moffett

connections to his own species. In this respect, our field of wildlife photography lags behind other forms of journalism.

The fault lies as much with editors as photographers. In any case, the scarcity of action photographs suggests opportunities for growth. Rather than improving graphic presentation of familiar events, we should look for new behaviors, new insights to surprise the reader.

JUMPING SPIDER

Reminiscent of dueling gladiators, these Sri Lankan jumping spiders spar with swordlike fangs. In this frame, the spider at right backs off and is about to flee with an apparent look of panic. The other rears up like a triumphant Rocky in the ring. Successful macro photography makes us forget size: these guys are 1/5 inch long. (I consider this an advantage. After all, hippos can only be smaller than life on the printed page!)

The best photographers strive for technical excellence without artifice (though action pictures commonly have the gritty realism of the finest human war images). "Bugs" can be quite expressive. Because of this, knowledgeable observers recognize contrived situations by subtleties of posture and action—as in vertebrates (for which, unfortunately, cage setups are equally common). Especially lamentable for insects are carefully staged photographs of refrigerated specimens. Indeed, to capture action in tiny subjects, composition cannot even be constrained by a tripod. I handhold cameras in nature at magnifications to x20. Depth of field may be the length of a paramecium (I have a steady hand). No modern gadget circumvents this. In fact, I choose camera models that existed long before I learned macro photography 10 years ago.

Olympus OM-2 camera, extension tubes and 38mm macro lens, Fujichrome Velvia film.

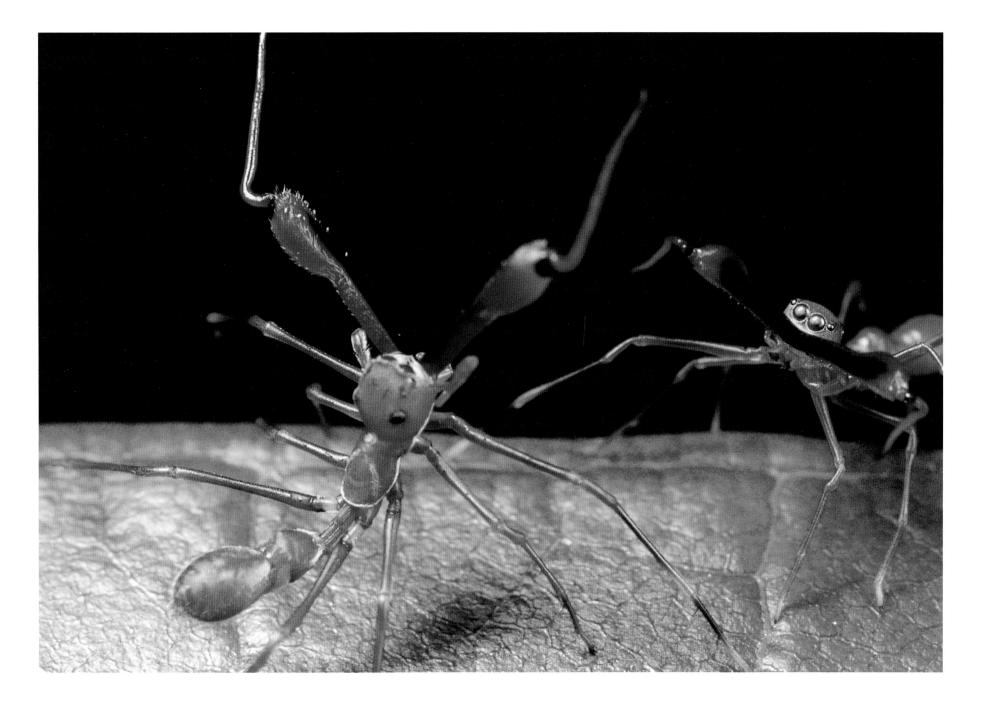

Jumping Spider

Mark W. Moffett

Flip Nicklin
UNITED STATES

• • • • • • • • • • • • • • • • • • •

My intent is to tell stories with pictures, and the stories most interesting to me have some element of surprise.

For example, I started to photograph whales at a time when they were portrayed as completely benign giants drifting in the blue abyss. I love working with whales, but wanted to illustrate the whole animal—mating battles, feeding strategies and other natural behavior. The same was true of my Arctic Bay work on narwhals. I could have dwelled on the coldest day in March, or how strong the wind could blow, but I was surprised to find mild weather for weeks at a time, when the water was flat and wildlife approachable. This is not to say that

CROSSED TUSKS NARWHAL

After more than three months of trying to photograph narwhal in the Arctic, I still had roughly "zip." The thought crossed my mind that a return to working as a SCUBA instructor might not be that bad.

I had been told wonderful stories about these mythical animals by Dr. John Ford and Debbie Cavanaugh, and I was eager to see one up close.

For the first few weeks, maybe months, of this endeavor, I felt I was always a step behind the action. After many missed opportunities, I was camped with John and Debbie in Baffin Island's Kaluktoo Bay, where they had their best success seeing, listening to, and photographing narwhal the year before.

On the last calm day of our stay, John came into camp to say he had found something we should see. He led us to three narwhal, two males with tusks and one dead or dying female. For the next seven hours we stayed with this group of whales and saw the males seemingly fend off any number of other groups that approached the female.

This picture is not of that frantic action, but a calm moment when the two males are slowly crossing their tusks over the now dead female.

I don't know the whys of this picture, nor can I even tell you all we saw in this space, but this is one of my favorite pictures. I like photos that let us wonder.

Nikon FM2 camera, 70-210mm Vivitar lens, Kodachrome 64 film.

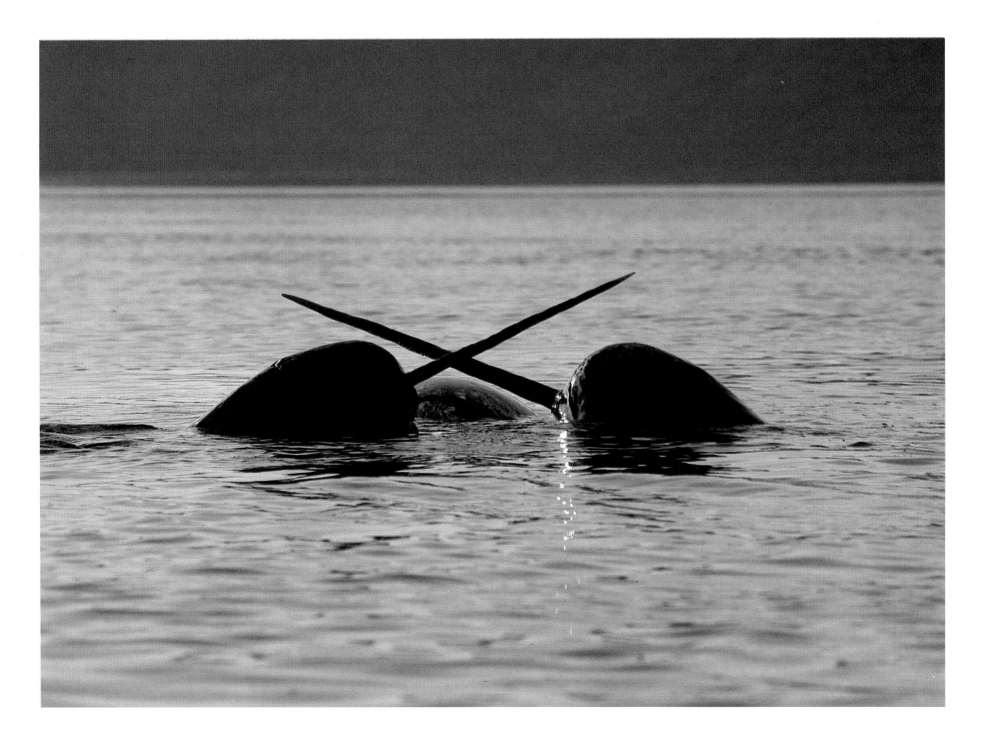

CROSSED TUSKS NARWHAL

Flip Nicklin

whales are not often gentle or that the Arctic cannot be harsh, but, instead, that more than one side of nature needs to be shown.

Photography has interested me since my first anchor-pulling work with National Geographic *photographer Bates Littlehales and my father, Chuck Nicklin. Three other key people also stoked my passion for wildlife photography: Dr. Jim Daring, who was studying humpback whales in Hawaii; Koji Nakamura, a great video photographer from Tokyo who, with his crew, were the best divers I had worked with, and seemed to know more about my backyard than I did; and Glenn Williams, a renewable resource officer from Arctic Bay, N.W.T., whose insight led me to see the importance of including man into the equation of a successful ecosystem.*

UNDERWATER BOWHEAD

This picture of an eastern bowhead whale is of a rare animal I never really expected to see, certainly not underwater. There may be no more than 500 of them existing today.

On ice that was three days by snow machine from the nearest Baffin Island town, I slipped into the water with an eastern bowhead whale after Glenn Williams and Seeglook Akeeagook had spotted the animal and sent word that this might be a good chance for pictures. I had grabbed my gear and raced to where they were watching the bowhead surrounded by beluga whales. Once in the water, I shot a roll of film and thought I had great stuff. Only on removing the film did I find the shutter frozen—literally—and the film unexposed.

Three years later and hundreds of miles away, I had a second chance. Kerry Finely had been studying a group of bowheads in a bay on the eastern Baffin Island coast and invited me to try to photograph them.

Wind and bears and tricky ice made this a really tough shoot, but Kerry paddled our kayak into position close to the animal. I swam up to the whale, his white chin appeared through the gloom, then his head, and when I was in position, the whale rolled under me to give me a look at his eye.

I hope to see and photograph bowheads again, but this first underwater picture will remain one of my most important shots.

Nikon F4 camera, 16mm Nikkor lens, Kodachrome 200 film.

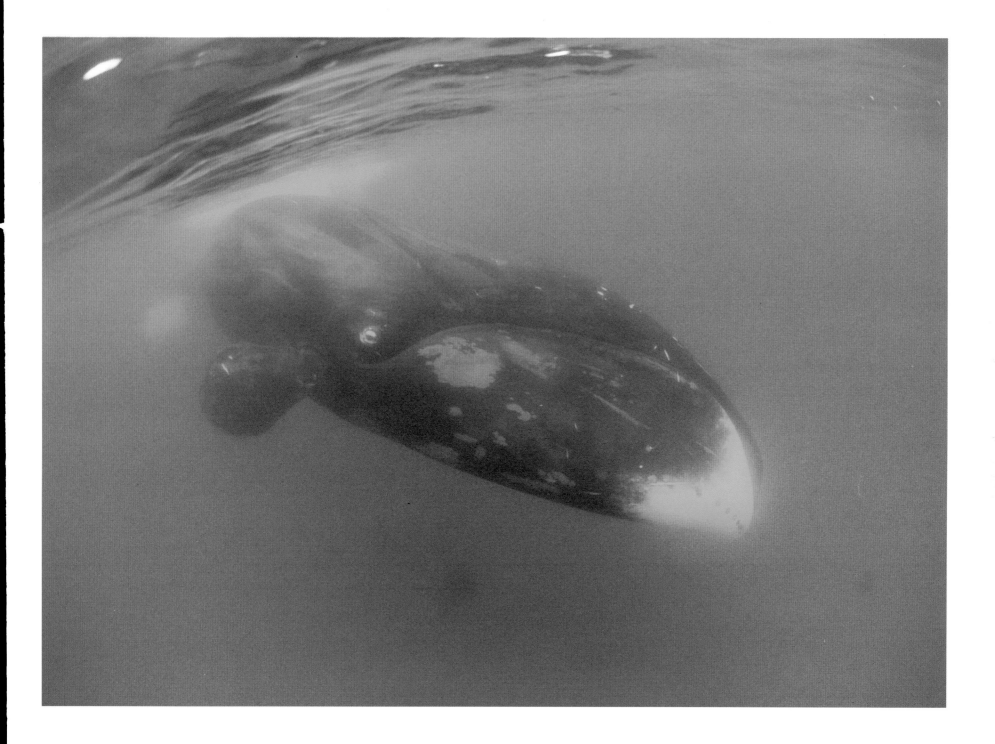

UNDERWATER BOWHEAD

Flip Nicklin

Spotted Dolphins

Spotted dolphins have been shot well by a number of top photographers, and researcher Denise Herzing's work is well known. I felt my challenge was to get the viewer to feel included in the dream of swimming with these wild cetaceans.

Toward that end, I spent hours in the water at Denise's shoulder, amazed at the time she could spend with her study animals and how relaxed and natural they were with her.

Fairly early in the coverage, a day came when everything was just right. The two animals were very friendly and easy to follow, and the action turned toward me to give me a good position for photography.

In addition to this being a picture of a researcher at work in rare harmony with nature, I think it is an interesting image, with the reflections that show the dolphins diving up and down at the same time. I also hope this picture is a view of how we now see whales and dolphins—not as alien shapes in the distance, but as part of a system in which all elements are important and need to be understood and respected.

Nikon F4 camera, 15mm Nikkor lens, Kodachrome 200 film.

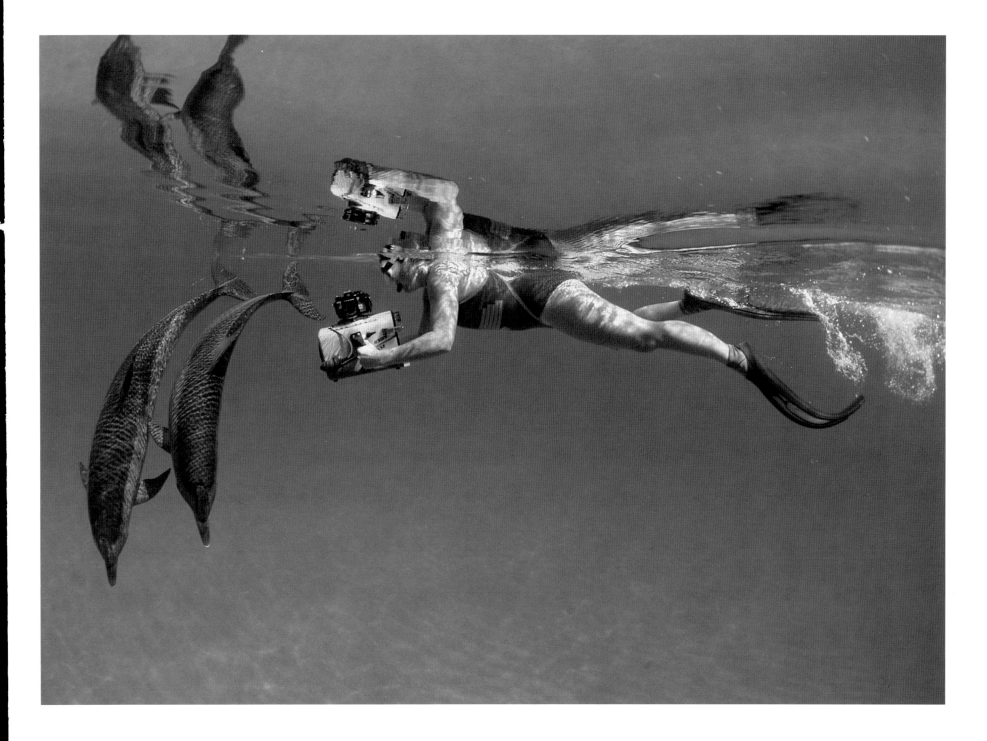

SPOTTED DOLPHINS

Flip Nicklin

John Shaw
UNITED STATES

• • • • • • • • • • • • • • • • • • •

I am a photographic generalist. That is, I photograph everything from mountains to mosquitoes, and all the subjects in between: landscapes, birds, mammals, insects, weather, flowers, patterns.

I prefer to go on extended field trips where I can become attuned to the natural rhythms of my subjects. My number one rule is to go out early in the day and to stay out late. The number of quality photos from any one trip definitely equates directly with the amount of time spent working a subject. And I always remind myself that regardless of how often or how much I've already shot a subject, the next frame may be an even better and more definitive photo.

BROWN BEAR CATCHING SOCKEYE SALMON

Katmai National Park, Alaska, is, in my estimation, one of the best and easiest places to photograph brown bears. The bears congregate in midsummer along the Brooks River during the sockeye salmon run. The more fish, the more bears and bear activity. Photographically, once you get to Katmai, it's just a matter of waiting until fish and bears come together.

The bears that gather at Brooks Falls have individually distinct fishing styles, learned primarily from their mothers. Some bears stand in the calmer areas below the falls, some plunge into the foaming water right at the base, and some stand at the extreme brink itself, seemingly about to tumble over the waterfall. This particular bear's fishing technique was to ease out to the very edge of the falls, wait for a leaping salmon to come directly toward him, then grab the fish in midair. I was amazed that in all the time I watched this bear, it never once was swept over the falls by the swift current, nor did it lose its balance while lunging for fish.

When photographing a subject such as this, you must anticipate any action. If you see anything happening while you're looking through your camera's viewfinder, it's already way too late to press the shutter. I watched this bear for some time, learning his behavior pattern, then waited for a major fish run up over the falls.

Over several hours of shooting, I got a number of good photos, but I like this particular frame—with the bear using its paw to sweep the fish into its mouth—the best.

Nikon F4 camera, Nikkor 300mm lens, Fujichrome 100 film.

118

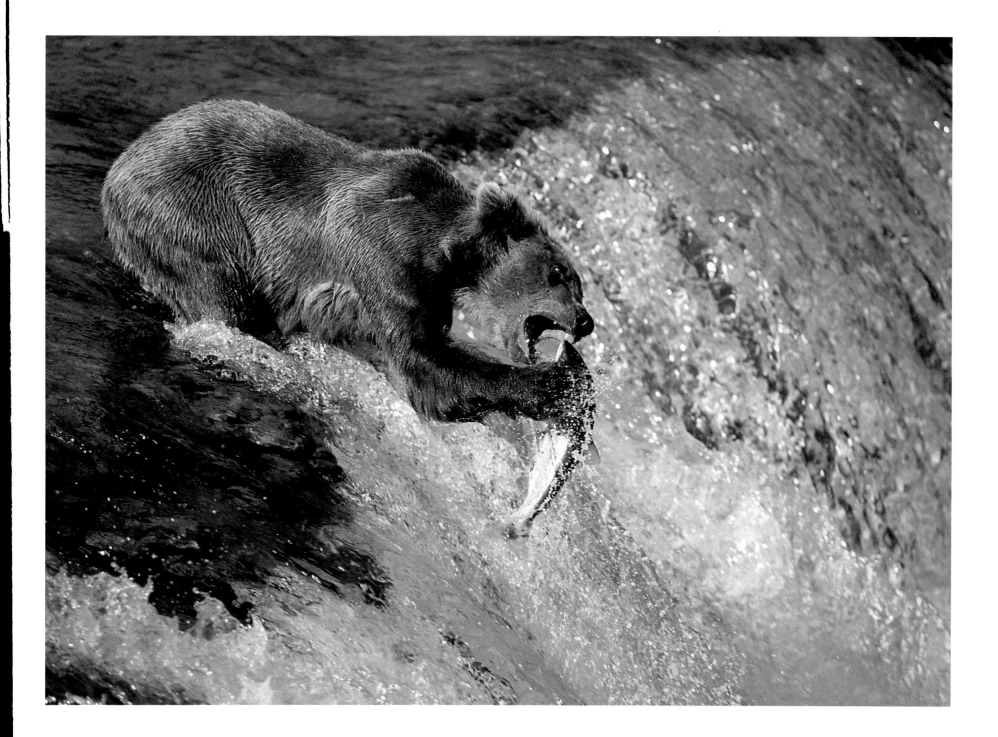

BROWN BEAR CATCHING SOCKEYE SALMON

John Shaw

The number of frames shot, by itself, however, does not equate with how good a photographer you are. I prefer to spend time and effort planning my shot, so that the results are more predictable.

Photographically, my cameras are always mounted on a heavy tripod. I use the best lenses I can afford with the slowest films I can use, given the lighting situations. Perhaps I'm a throwback to an earlier time, but I still use the manual exposure mode with manual focus lenses. On field trips, I normally carry at least two camera bodies and focal lengths from 20mm to 500mm. My work is almost exclusively with 35mm cameras, although I have done some large format photography and continue to shoot with a 6x17cm panoramic camera.

In terms of composition, I have a favorite catch phrase, doing not "photography" but rather "photo-graphics." This means not merely recording a subject, but doing so in a pleasing manner, aware of and using all the elements of design.

RED-BANDED HAIRSTREAK BUTTERFLY

I've been interested in photographing butterflies for many years. The first time I went to south Florida, I saw a single red-banded hairstreak, and after hours of chasing it, I succeeded in shooting exactly one frame. But the butterfly was a beat-up, tattered specimen, so my one-and-only picture of the one-and-only red-banded hairstreak I had ever actually seen was a pretty wretched photo. My subsequent trips to Florida were all at a different time of year, and I never saw another red-banded hairstreak.

Over 20 years later, my wife and I were living in North Carolina. While putting away my lawn mower one day, I was startled to see a freshly hatched, perfect specimen red-banded hairstreak sitting on my garage door. Abandoning my mower, I ran inside, grabbed my camera gear, and ran back out. The butterfly was still there. I flushed it off my garage, then followed its flight into the field next to my house. In my excitement, I cranked off six rolls of that one red-banded hairstreak butterfly. Ironically, within a few days I discovered a colony of them living right on my property. In fact, as that summer progressed, I found red-banded hairstreaks on my deck, in my front yard, on my patio, and even a few flying into the house as I opened the doors.

Nikon F4 camera, Nikkor 105mm macro lens, flash, Fujichrome Velvia film.

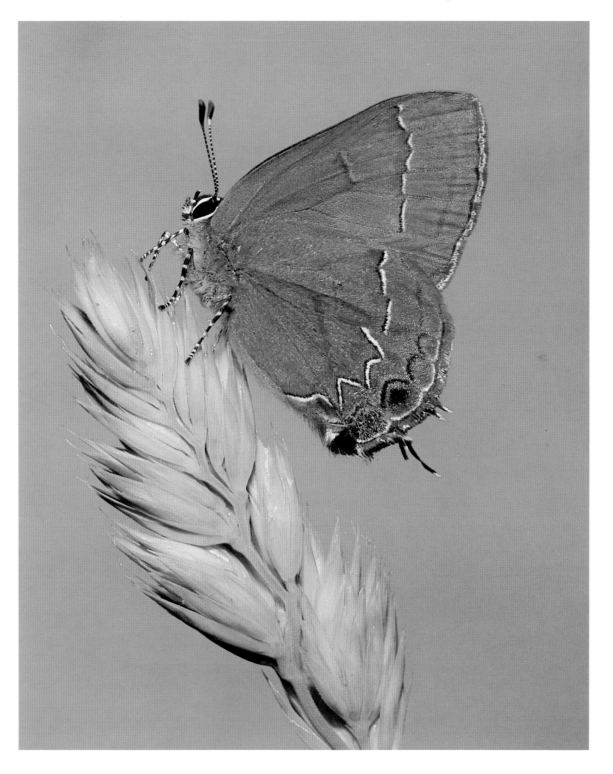

Red-banded Hairstreak Butterfly

John Shaw

BALD EAGLE LANDING

Every November, there is a late season chum salmon run in the Chilkat River, near Haines, Alaska. This is the last major food source of the year for bald eagles in southeast Alaska, and consequently several thousand birds gather along a 20-mile-long section of the river. This event is so unique that the State of Alaska has designated that stretch as a bald eagle sanctuary in which visitors and photographers are restricted to the river bank and four vehicle pull-offs.

It's not the easiest place to photograph: normal conditions at the peak time are overcast, dreary days with wet snow and penetrating dampness. The rare sunny day in the river valley, with birds close, is a time to shoot, shoot, shoot.

On one such day I found a location where several spawned-out salmon were stranded on gravel bars near the shore. Adult eagles would come in for the fish, dislodging other eagles already there. I set up my tripod in the only position possible and waited. One bird came in for a landing directly toward me, so I could follow-focus with my 500mm lens and motor-drive camera. I particularly like this shot with the wing tips outspread. A single down feather, displaced in landing, is visible as it drifts down from the bird.

Nikon F4 camera, Nikkor 500mm lens, Fujichrome 100 film.

BALD EAGLE LANDING

John Shaw

Larry West
UNITED STATES

• • • • • • • • • • • • • • • • • •

Thoreau said, "the heart is not a traveler," and I believe this. I live amid the scattered wetlands and wood lots of southern Michigan, and do most of my photography there—either in my 27-acre backyard, or within 10 miles of my house. I love to witness the visual revelations brought on by changing seasons, weather, and light, and I learned long ago that you don't need to travel to find these things. Any woodland or meadow is filled with subjects that—in their proper season, at the right moment, in the right light—become transcendental.

My area offers few grand landscapes, but holds a nice mix of floral and animal subjects. White-tailed deer, mink, great blue herons, cardinals and

HONEY BEE ON MILKWEED

Prepared with close-up techniques I've developed over many years, and with a knowledge of insects gained from a lifetime of study, I often wander through meadows and fields in search of subjects. At these times, I'm not seeking anything in particular, but I remain open to situations as they present themselves.

This photograph of a worker honey bee on orange milkweed resulted from one such random encounter. One warm July afternoon, a friend and I wandered about a field of orange milkweed plants, searching for the diminutive hairstreak butterflies that often take nectar from the blossoms. No butterflies were on hand, so we spent some time photographing the abundant honey bees. We took turns stalking, one of us with a hand-held flash setup in front, while the other held a second flash behind the bee, giving studiolike lighting to the composition.

Nikon 8008 camera, 105mm macro lens with a 52.5 extension tube, two electronic flashes, Fujichrome Velvia film.

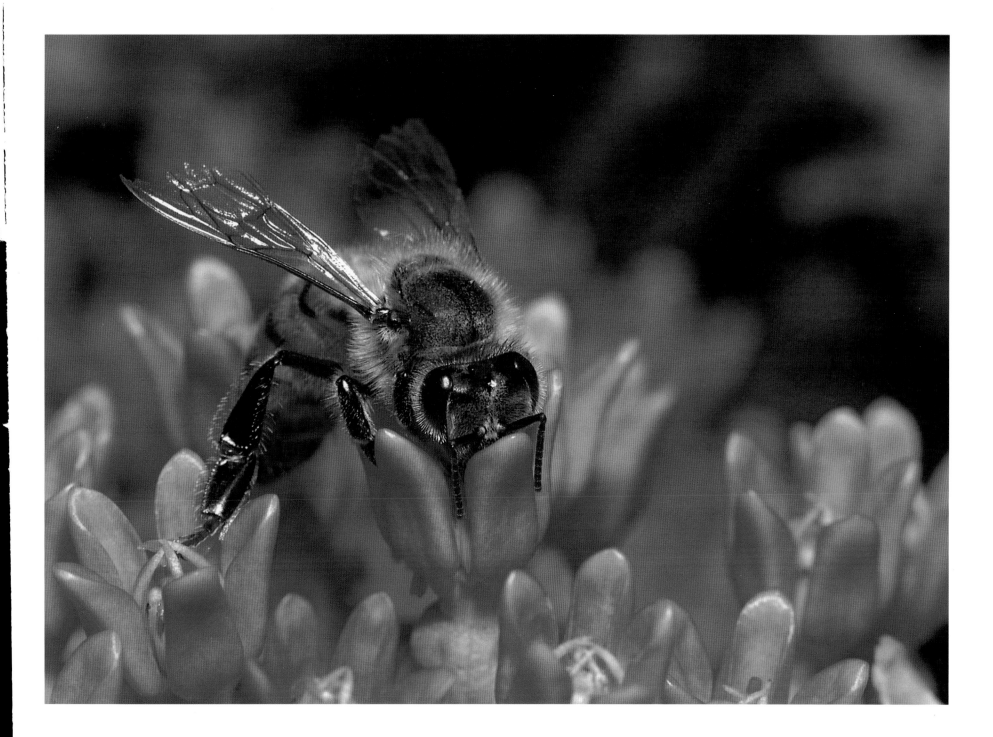

Honey Bee on Milkweed

Larry West

bluebirds, green frogs, butterflies and many other animals come and go through the year.

By photographing close to home, I'm assured of being present and prepared when subjects, weather, and light come together to create optimal conditions.

There are other advantages to photographing close to home as well. Wallace Stevens wrote, "there are people of a valley who become the valley." This is certainly true for wild creatures. They exist as organic personifications of their native landscape. By getting to know one place well, you come closer to understanding, and to becoming a part of the essence of that place. This intimate knowledge of place allows you to go beyond the obvious, past the clichés, to see the subtleties of behavior and gesture that make each species— each individual—unique.

I don't hurry well. I like to be with subjects long enough to allow interesting things to happen. I need time to look deeper, to see beyond the things that I already know how to see. Much of my work is like revisiting old friends to see how they've changed, how they've fared over the year. For me, it's the difference between being a tourist photographing strangers, and being a part of a community, recording the

BISON ON GOLD

A love of pronghorns led to this photograph of a bison in Wind Cave National Park. Over several years, I made a number of trips to the park to photograph them at various seasons. My technique was to find a pronghorn, then follow it across the prairie with my tripod and long lens until an interesting situation presented itself.

One morning, I trailed a young buck for a half mile over rolling hills. The elements of a photograph began to come together as a band of dark clouds formed in the eastern sky above a band of lighter gold. The final piece fell into place when a bison appeared on a nearby ridge. I arranged the components by moving to where I could place the bison against the gold sky, framed by the storm clouds.

Nikon F3 camera, 500mm lens, Kodachrome 64 film.

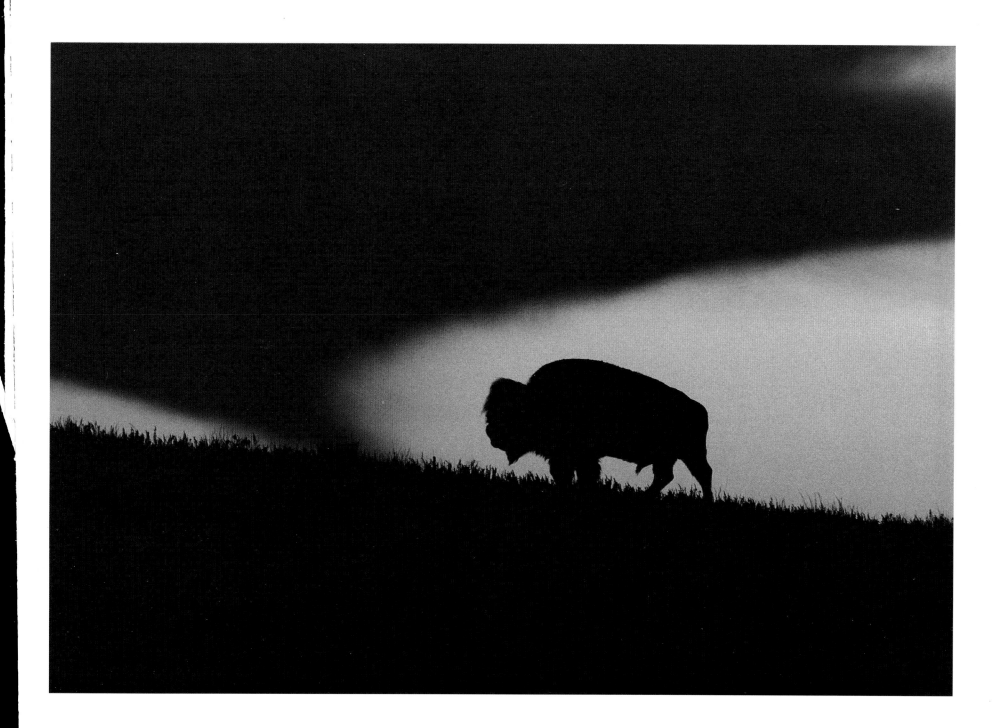

BISON ON GOLD

Larry West

intimate details of the lives of loved ones.

I work to make my wood lot attractive to wildlife by adding appropriate plants for food and cover and installing nesting boxes and winter feeders. This increases the diversity of wildlife on my land and lures subjects in front of my camera. The fact that my 27 acres is still a good home for its native creatures, and is wilder and more diverse than it was 20 years ago, gives me as much satisfaction as the images I find there.

CARDINAL IN WINTER

Like much of my work, winter bird photography is part of the annual cycle of my life, and I've photographed cardinals in my backyard for many years. Some individuals I've known for six years, having spent countless hours with them through frigid weather, snow and ice storms.

My preparations begin in late autumn, when I move my blinds into place. By the time the first snows fall, the blinds have become a part of the birds' landscape, as familiar to them as the surrounding trees and shrubs. By midwinter, I've become an accepted part of the birds' world and my comings and goings cause little concern. Then I'm free to watch them live their lives for hours at a time without disturbing them. Under these conditions, with the birds at ease—brilliant red against the muted browns and whites of a Michigan winter—it's hard to make a bad image.

Nikon 8008 camera, 400mm lens with 1.4x multiplier, Fujichrome 100 film.

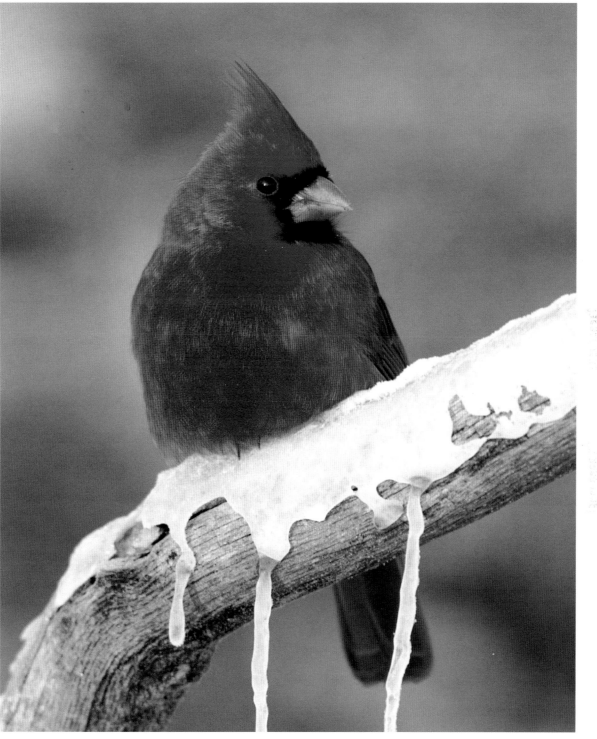

CARDINAL IN WINTER

Larry West

Art Wolfe
UNITED STATES

• • • • • • • • • • • • • • • • • • • •

Success as a photographer, as in most professions, hinges on zeal and timing. I feel extremely fortunate to be doing something I love, and to be doing it well. I am thoroughly absorbed by and passionate about my work. It is my chance to communicate to people what I think is important, and if people are touched in a positive way, I have done my job well.

Rarely seeing my Seattle home more than three months out of the year, I am almost constantly on the road, but rarely out of touch with my studio. This close communication allows me the freedom to photograph, and the

LESSER FLAMINGOS ON LAKE MAGADI

A young French microlight pilot, commissioned by Amboseli National Park to do aerial surveys, had graciously allowed me to tag along with him. After doing some work over Amboseli, I persuaded him to take the microlight a hundred miles away to photograph the dramatic migration of flamingos along the briny lakes of Kenya's Rift Valley.

One of the reasons I like this photo so much is that it is not an obvious shot when first seen. There is a sense that one is looking up at a flock of birds flying against gray clouds; upon second glance, one realizes that they are casting shadows upon the water's surface. To be flying above flying birds is a unique perspective not often captured.

A microlight is infinitely more maneuverable than an airplane or a helicopter, and certainly more quiet. However, flying along with the birds was quite disorienting, and could have been disastrous. When flying over a very calm lake, height and distance become extremely difficult to read, and at times we found ourselves dangerously close to the surface. It is not unheard of for a microlight pilot to crash as a result of a misjudgment of altitude. But in this adventure, the pilot and I happily survived to fly and photograph another day.

Nikon F4 camera, Nikkor 80-200 zoom lens, Fujichrome Velvia film.

LESSER FLAMINGOS ON LAKE MAGADI

Art Wolfe

KING PENGUINS AND ELEPHANT SEALS

South Georgia, a subantarctic island about 100 miles long, is a very remote, rich ecosystem. Once a year, seals and penguins come ashore to molt and breed. For all their size and bulk, elephant seals are fairly benign, except for when they barrel over nesting penguins, crushing them and their eggs.

I was there in the summer, January, when beaches were covered with activity, flooding the senses. The biomass was tremendous.

This photo is one of my favorites because it has so many things happening—the four king penguins in conference in the left corner and the sparring elephant seals surging through the sand. The penguins are almost comical in their anthropomorphic stances. The atmospheric conditions, with the heavy mist of wind-blown sea foam, bathes the entire scene in a sort of primordial fog. Despite this, the main characters in this nature play are all in focus. Merely engaged in a minor altercation, the young bulls were learning to fight. As they mature, their fights will become more intense and sanguine. The unconcerned penguins—they themselves standing over three feet tall—are just a few feet from the huge seals.

The subdued light is a double-edged sword: it certainly gives the photo a timelessness and highlights the subtle orange auricular patches of the penguins, but it also can ruin shots. There was only a moment when there was a pause in the action and a successful shot made. Such images are only gotten with timing and a bit of luck.

Nikon F4 camera, Nikkor 200-400mm lens, Fujichrome Velvia film pushed one stop.

King Penguins and Elephant Seals

Art Wolfe

LONE ZEBRA AMIDST WILDEBEEST

The annual wildebeest migration in East Africa is one of the greatest spectacles in nature. By the tens of thousands they back themselves up against the Mara River, terrified to cross because the innate learning of millennia warns them of the crocodiles lurking in the churning waters. Zebras, too, get caught up in the migratory frenzy, and sometimes, by the sheer force of bodies, are cut off from their herds.

As are many of my shots, this picture was completely unplanned; it simply unfolded before me. This lone zebra was separated and engulfed by a sea of moving, grunting wildebeest. I waited for the instant when the confused zebra turned directly into the herd, and to add a sense of tension to the image, I framed it off-center. Therefore, the eye is drawn across the backs of hundreds of brown wildebeest straight to the gaudy stripes of the zebra.

To find a single animal which is completely different from the rest creates a sense of drama. Aside from its vivid color, the zebra is even more apparent because it is standing on a rise within the herd of wildebeest. The light was nicely overcast, enriching the warm colors, and allowing me to use a long lens to compress the image.

Nikon F4 camera, Nikkor 600mm lens, Fujichrome Velvia film.

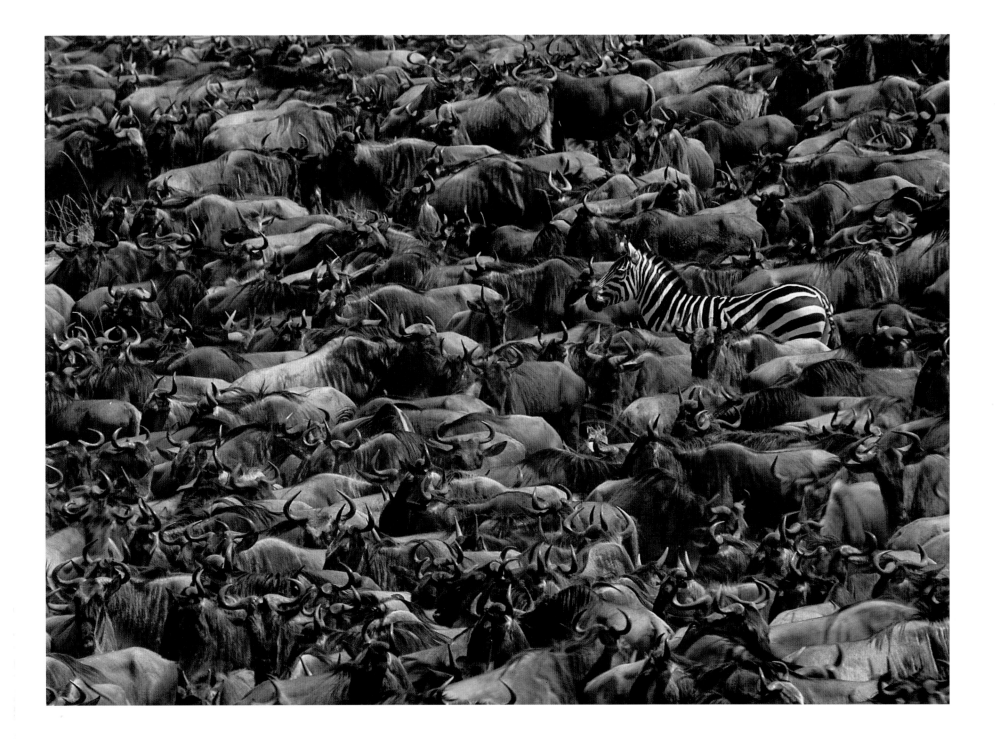

Lone Zebra Amidst Wildebeest

Art Wolfe

Günter Ziesler
GERMANY

• • • • • • • • • • • • • • • • • • •

My specialty is not to be specialized. I love all that is wildlife, be it a minute insect or a majestic tiger. I also love nature's different expressions and landscapes, from the abundance of life in a tropical rainforest to the arid desert. Thus, I wish to spend my life traveling as far and as much as I can, to experience the world, always in search of beauty and harmony.

Obviously, I have evolved some preferences during the past 20 years; I prefer wide, open landscapes to forests. I generally find forests a little boring, except for the various forms of rainforest. A tropical rainforest with its abundance of life forms and secrets fascinates me most. Unfortunately, it is also one of the most difficult places for a wildlife photographer to work.

With such an inclination towards open landscapes, one could assume that

MACAWS ON THE COLPA

In some areas of the South American tropical rainforest—mainly on the steep banks of a river—there are places with mineral rich soil, called "colpas," which are very attractive to many animals living in the rainforest.

Tapirs, peccaries and monkeys regularly come to the colpas to feed on the mineral rich soil. Birds, too, mainly parrots, are regular guests there. The most prominent and frequent visitors are the big colorful macaws.

One such colpa is situated in the upper course of Rio Manu, in Manu National Park, which I visited while preparing a book on the National Parks of Peru.

I spent my first day in a hide on the opposite bank, to find out where and when the macaws would land to feed. Then I had to solve the problem of building a suitable hide. The opposite bank was too far away and the water was too deep directly in front of the colpa, but some moving soil had built up at the end of the colpa. There I constructed my hide, covering it with fresh vegetation. I was worried that the birds wouldn't accept a hide that close, but the macaws seemed not to be bothered at all. Maybe they were quite used to changes in the surrounding area due to the frequent soil movements on the river banks.

This setup put me quite close, but my camera point was at an oblique angle. To get all birds in focus, I had to use a lens aperture of f16-22, leaving me with a shutter speed of 1/8th and 1/15th second.

Nikon F2 camera, Nikkor 105mm lens, Kodachrome 64 film.

136

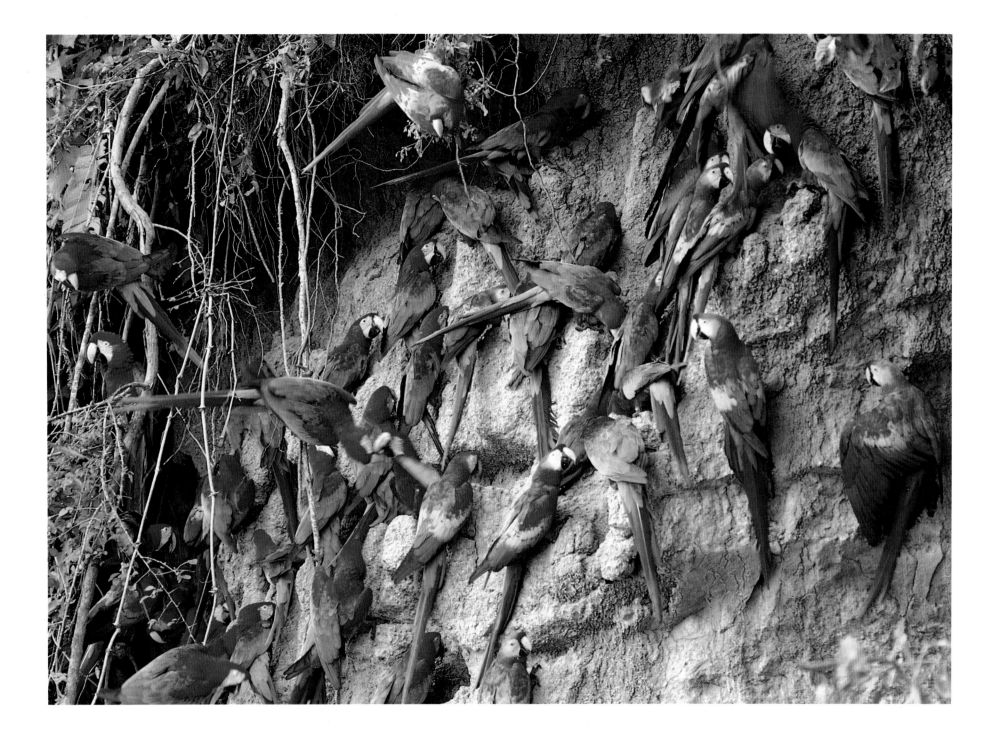

MACAWS ON THE COLPA

Günter Ziesler

sooner or later I would end up in the open savannas of Africa. The hindrance was one elementary need I have: to be alone when I am at work. But to be solitary in an area so rich in wildlife is nearly impossible.

Once I spent a year in Kenya, and despite roaring cars and tourists, I got some very good material, yet never felt at ease there. For me, it was quite a stressful time, not only because there was so much to do, or because the numbers of tourists sometimes interfered with the wildlife, but mainly, it was having to make the decision of where to go every day that got on my nerves. I was always hoping to be at the right place at the right moment.

Even though I wouldn't have wanted to miss the Masai Mara, I prefer to wander through a rainforest, not encountering another human being for days on end.

Another important aspect of my life and work is my colleague and partner, Angelika Hofer. Maybe it's because we are so different that each one of us profits so much from the other. Angelika has a talent in dealing with people, which I more or less lack. Her friendly nature has opened many a door for me which might otherwise

MUTE SWANS IN A SNOW STORM

We live in Füssen, a small Bavarian town at the northern end of the Alps. We can look at the famous Neuschwanstein castle out of our window, and only half a mile away from it lies, nestled in the mountains, a small lake, called Swan's Lake. Maybe it owes its name to the mute swans that have nested there for ages.

Being situated 800 meters above sea level, frost and snow, even in April, are not a rare occurrence. Mute swans, however, start to nest in March. One April day, we had a rather heavy snowstorm, covering fields and meadows with a snowy blanket of white, which melted the same day.

I left my work at home and rushed to Swan's Lake, where I photographed the nesting female, totally covered in snow, but dozing, unimpressed. The male, however, immediately approached to defend its nest and mate, spreading its wings and moving upwards.

Nikon F3 camera, Nikkor Zoom 35-70mm lens, Kodachrome 64 Professional film.

138

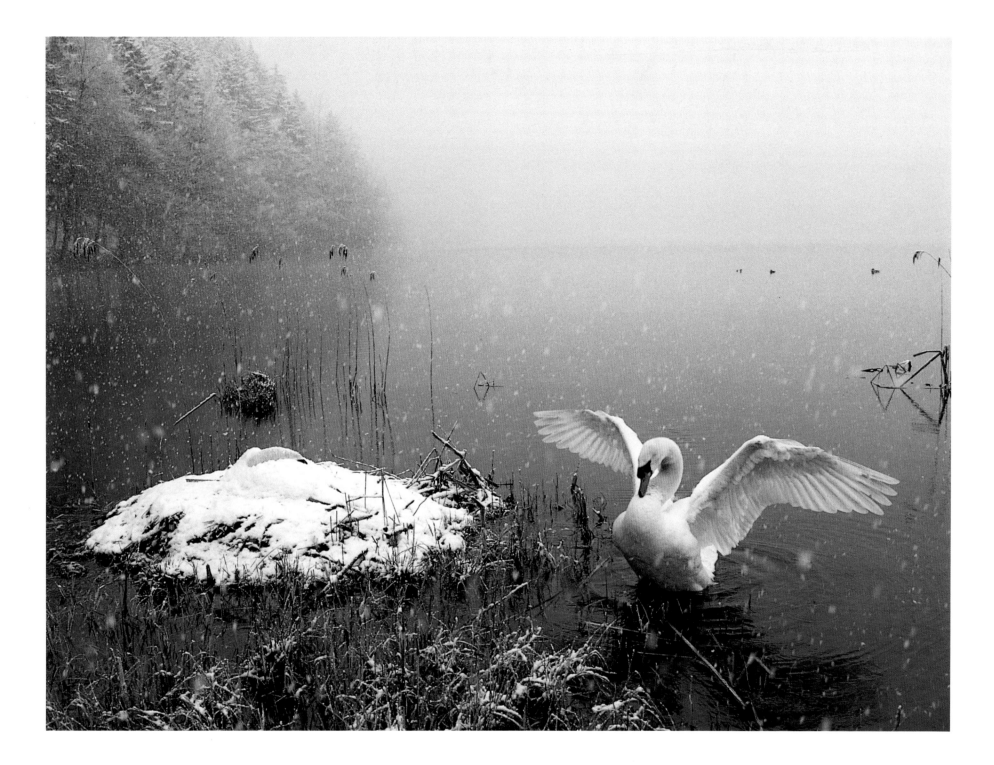

Mute Swans in a Snow Storm

Günter Ziesler

have stayed closed. And I am quite sure that some of my photographs wouldn't have been taken without her patience and endurance.

HUNTING CHEETAH

One afternoon in the Masai Mara, we experienced a unique situation. We were moving around with our VW camper when we encountered a male cheetah that was stalking Thompson's gazelles. And, miraculously, we were all alone with this cheetah. No tourist bus or other vehicle came in sight.

I planned to portray the enormous speed of the running cheetah by moving parallel to it with my camera, using a slow lens speed.

After a nerve-wracking wait of a few minutes, the moment came. The cheetah had managed to move close to a group of Tommies, using some termite mounds as hides. Suddenly it started its sprint. It was not an easy task to focus on the running animal (autofocus at that time only existed in the minds of the engineers), but I was lucky.

Unfortunately for the cheetah, the hunt ended without success.

Nikon F3 camera, Nikkor 400mm lens, Kodachrome 64 film.

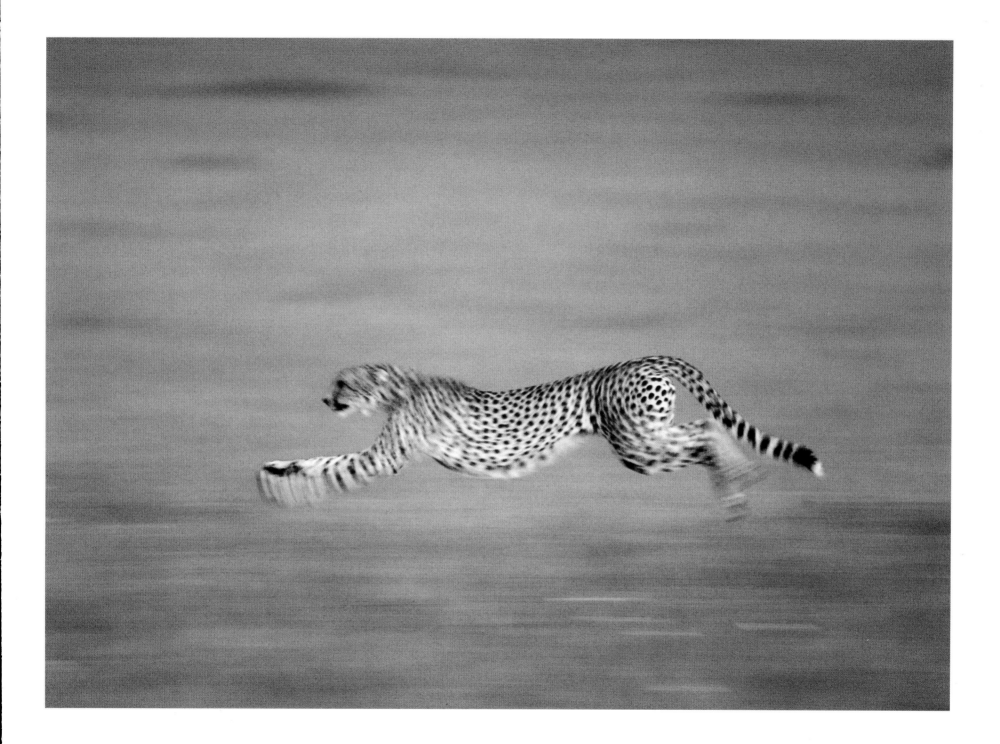

HUNTING CHEETAH

Günter Ziesler

George H. Harrison
Author/Editor

George H. Harrison is an award-winning nature writer, photographer, book author, video host, and consultant in the field of nature and the outdoors.

Harrison is Nature Editor for *Sports Afield* and Field Editor for *National* and *International Wildlife* magazines. He has authored or co-authored eight books including *The Backyard Bird Watcher*; *America's Favorite Backyard Birds*; *America's Favorite Backyard Wildlife*; and *The Birds of Winter*.

Videos include *George Harrison's Birds of the Backyard—Winter Into Spring* and *George Harrison's Spring and Summer Songbirds of the Backyard*.

He is the 1981 recipient of the Jade of Chiefs Award, "For distinguished service to conservation," presented by the Outdoor Writers Association of America (*OWAA*). Harrison is President of Harrison Productions, Inc., a nature communications firm in Hubertus, Wisconsin.